IMAGES
of America

ESSEX

In 1638, the Sagamore (chief) of Agawam, Masconnomo, signed two deeds giving Agawam (which contained Essex) to Ipswich for 20 pounds. He was from the Pawtucket tribe, which was closely related to the Massachusetts. This signing was a symbolic transfer of culture. While the Europeans found the land to be a wilderness, it was actually extensively used by the native people. A 1615 record of Cape Ann, written by John Smith of the Jamestown Colony, noted that our "delightful groues . . . make this place an excellent habitation." This flattery almost swayed the Plymouth Colony to settle here. (Courtesy Massachusetts Registry of Deeds.)

ON THE COVER: This image displays Frank Haskell's Blacksmith Shop on Main Street in the 1880s. Standing in the doorway are, from left to right, J. Henry White, Caleb S. Gage, blacksmith Otis Story, John Morse at anvil, wheelwright Thomas Gage, Francis P. Haskell, and Aaron Cogswell with his accordion. (Courtesy Essex Shipbuilding Museum.)

IMAGES
of America

ESSEX

Dawn Robertson and Kurt A. Wilhelm

ARCADIA
PUBLISHING

Copyright © 2010 by Dawn Robertson and Kurt A. Wilhelm
ISBN 978-0-7385-7279-6

Published by Arcadia Publishing
Charleston SC, Chicago IL, Portsmouth NH, San Francisco CA

Printed in the United States of America

Library of Congress Control Number: 2009938115

For all general information contact Arcadia Publishing at:
Telephone 843-853-2070
Fax 843-853-0044
E-mail sales@arcadiapublishing.com
For customer service and orders:
Toll-Free 1-888-313-2665

Visit us on the Internet at www.arcadiapublishing.com

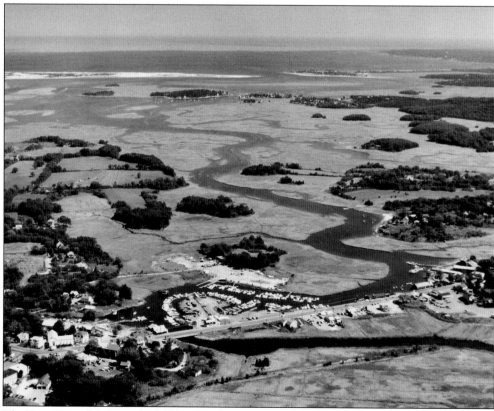

The Essex River has been the lifeblood of the town of Essex. Thousands of Essex-built schooners and other vessels have been sent downriver to begin careers as fishing vessels, freight carriers, and pleasure boats. Clams still provide employment for diggers and stock for the many restaurants. Today the waterway is extensively used for recreation. (Courtesy Todd Lyon, The Flying Lyon.)

CONTENTS

ACKNOWLEDGMENTS

In creating a book of this nature, the authors are, in many ways, simply the grateful recipients of a tremendous amount of passion and work done by many people throughout the area and throughout time. Joseph Felt and Reverend Crowell both wrote town histories in the mid-1800s that border on obsessive and capture the academic history of this area. We thank Courtney Peckham for her insightful first volume *(Essex Shipbuilding),* which gave us a wonderful example to live up to. Leslie Harris's *150 Years a Town* was a priceless resource during the whole process, and Elizabeth Waugh's volume on the native local history filled a longtime need regarding local heritage.

The town is indebted to Dana Story, as his dedication to Essex history and his collection efforts are without parallel. His collection makes up the bulk of images housed at the Essex Shipbuilding Museum. Phillip Stevens also has a wonderful collection of town images, and we appreciate his generosity so much. We also have a great new friend, Kristen Weiss at Historic New England's Cogswell's Grant, who supported us with enthusiasm and efficiency. Megan MacNeil at Historic New England's archives gave us superior service, and Stephanie Buck at the Cape Ann Museum was a wealth of information. We are also so thankful for Cindy Cameron, Frances Elwell, John Ratti, and Michael Gray, who specifically assisted us in our pleas for help. We also offer our broad appreciation to all those who answered our call for support and guidance.

Unless otherwise noted, all images in this volume are from the collection at the Essex Shipbuilding Museum.

INTRODUCTION

While humans have been living in Essex for over 11,000 years, the age of photography began about 150 years ago. This introduction offers a succinct look at the first societies that lived here and how the population shifted from Native American to European to Yankee. The rest of this volume offers a captivating glimpse into our more recent heritage.

As the last Ice Age retreated to the Canadian border, Native Americans moved north to hunt the cold tundra for large, now extinct animals. These mobile hunter-gatherers left behind artifacts as they followed caribou routes up the coast in spring. The Bull Brook Site in Ipswich is one of the largest Paleo (9,000 to 5,000 BC) sites in North America; it has produced over 8,000 artifacts that are similar to remains found all over Cape Ann. The site revealed small, local bands of families fishing, hunting, cooking, building, and traveling far with the seasons.

During the early and late Archaic Periods (5,000 BC to AD 300) the climate grew warmer, the animals grew smaller, and people began domesticating plants. Artifacts on Choate Island in Essex (shell middens, stone and bone tools, pottery shards, and various animal bones) show that natives called Essex home well into the Archaic Period. Spear points, arrowheads, fishing line sinkers, net weights, bone implements, mortars and pestles, hammers, scrapers, axes, hoes, and knives found on the mainland all point to an evolving culture and landscape across Cape Ann.

The later Woodland Period (AD 300 to 1676) is marked by more permanent settlements, pottery, and recognizable food. The soil was suitable for corn, beans, melons, pumpkins, tobacco, grapes, and squash, and the waters teamed with cod, alewife, mackerel, herring, flounder, salmon, cod, lobster, clams, and scallops. In Essex, the natives' yearly migration from winter to summer homes required a simple 30-mile trip inland. Elizabeth Waugh reminds us in her book *The First People of Cape Ann* that they had "no metal, no wheels, no sails, no domestic animals aside from dogs, and no written language." The Late Woodland people are the famous Native Americans that befriended or fought the Europeans in the early 17th century.

European dominance here was swift, tragic, and almost unintentional. Samuel de Champlain first mapped Cape Ann in 1605 and describes joyous, thriving native people with rich gardens and bustling towns. In 1611, British captains Harlow and Hobson explored New England's coast on a trading (and slaving) expedition. They met the friendly Pawtucket people, closely related to the Massachusetts, in the land called Agawam, which means "abundant fish." Agawam spanned from the Merrimack River to the Salem River and to Andover on the west (thus containing Essex). The next record of Cape Ann was written in 1615 by John Smith of the Jamestown Colony. This early communication ranged from inquisitive to disrespectful, friendly to deadly, but all of it unfortunately caused a catastrophic smallpox epidemic in the native New England population that nearly erased it within a few years (1615–1619).

The birth of Essex involves a quick timeline. In 1620, the Plymouth Colony settled in Massachusetts, and in 1628, the Massachusetts Bay Colony purchased land from them. In 1633, the Massachusetts Bay governor in Boston had his son settle 30 miles north in order to defend

the colony from native and French threats, and this outpost was called Ipswich. In 1634, a few men settled the new Ipswich neighborhood of Chebacco, an area that would split off and become Essex in 1819. William White, John Cogswell (ancestor of Oliver Wendell Holmes and Ralph Waldo Emerson), and Goodman Bradstreet were all successful businessmen from London and became the first Essex citizens.

In 1638, the Sagamore (chief) of Agawam, Masconnomo, signed two deeds giving Agawam to Ipswich for 20 pounds. Town records describe these two cultures intermingling quite a bit; they traded, quarreled, and defended each other for many years. A 1644 agreement put the natives under the care of Ipswich, as Masconnomo's people by then were broken from disease, threatened by attack from other natives, and crippled by bizarre new concepts of land ownership and unfair trade. His sad and humble voice is heard in this agreement, acknowledging that for some divine reason, it was time for a stronger people (with stronger illnesses) to take the Native Americans' place in Agawam. While town records show native people receiving care well into the 18th century, the culture basically vanished.

To Europeans the land was a true wilderness, and life was hacked out of difficult terrain. Records describe pirate abduction, Native American kidnapping, military expeditions, animal attacks, typhus, and smallpox. Life completely revolved around the church, crops, and family. Yet the settlers survived. They grew hay, barley, wheat, vegetables, fruit, hemp, and flax and raised horses, oxen, cows, sheep, and pigs. The first grant of land for a shipyard in Essex was created in 1668 and the first Chebacco boat was built in a Burnham house in 1660—these are quaint harbingers of a future powerhouse economy.

Chebacco petitioned Ipswich for its own church in 1676, but the court hesitated, as a new church meant that the worshippers' taxes would go to the new group. After a couple years of bureaucracy, Chebacco started raising its own meetinghouse, but the court quickly forbad any man from completing the project. So, with help, a few clever women finished the job. They were first found guilty but later pardoned, and by 1680, Chebacco had its own church, minister, graveyard, and boundary line. By the end of the 17th century, there were 3 bridges, 5 mills, a shipyard, a church, tavern, and 300 people thriving from farming, fishing, and boatbuilding.

In 1700, the landscape was still very wild. Children were forbidden to travel solo to church or school for fear of wolves. Land grants were given to anyone (that is anyone white, male, and a member of a Congregational Church) who could make it useful to the town. Carpenters, blacksmiths, tailors, rope makers, farmers, butchers, millers, brewers, clam diggers, tanners, and boatbuilders created a strong economy and increased trade improved the quality of life. Houses gained glass windows and paint, and the town gained roads and bridges.

Various regents, governors, and currencies created a tumultuous political and economic landscape, and Chebacco followed every minutia of Boston politics. Over 100 Essex men fought in the Revolutionary War, some directly under Washington. Many town men died, including an African American man—unusual since the draft did not necessitate African American involvement. Essex subsequently sent delegates to three constitutional conventions. By 1800, there were 2,000 Chebacco boats fishing off of Cape Ann, and the population was at 1,100.

In the early 1800s, the town was poised to become a flourishing center of industry. Chebacco split from Ipswich in 1819 due to its separate economy and identity, and the new Essex leaders had familiar names: Choate, Cogswell, Burnham, Story, and Andrews. Farms, mills, icehouses, and a large shoe factory prosper. The population fluctuates between 1,300 and 1,700 all century, but ship production grows exponentially, as boats are abandoned for full-rigged schooners and these get increasingly larger throughout the century. It cannot be overstated how much this industry guided Essex's success. Shipbuilding waxed and waned with wars, weather, and the economy, but by the close of the industry in the late 1940s, around 5,000 vessels had been built, more than any other town in America.

One

THE ESSEX RIVER AND NORTH END

Much of coastal Essex is marshland. The Essex River has defined the character of the town since its settlement. The North End of town is admired for its scenic farmland viewed when entering Essex from Ipswich. David Choate's 1853 map shows some early-17th-century roads, as well as those existing in 1853.

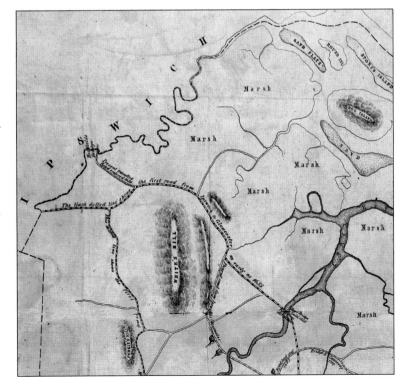

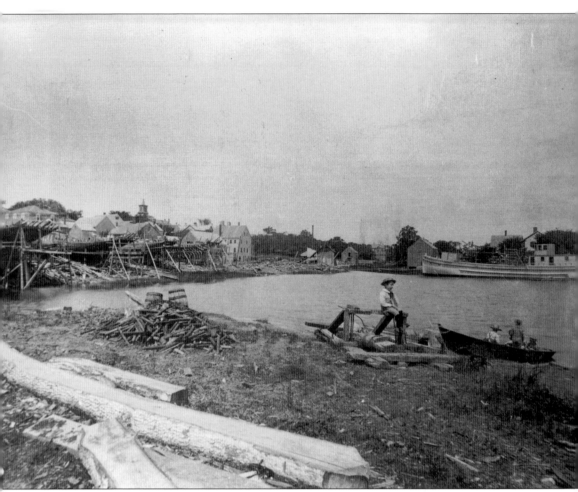

Young A. D. Story Jr. (1884–1904) sits in the foreground of this 1893 view of the river basin. His father's shipyard has six vessels under construction. The steam lighter is probably the 93-foot *Margery*, which was built at the A. D. Story yard and launched in 1893.

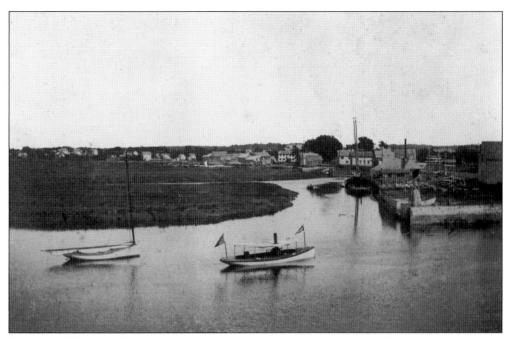

This part of the Essex River has changed dramatically since this photograph was taken. The piece of marshland just behind the boats was an island. It is now connected to the causeway, and the river flows around on the far left side of the land. Pictured is a fantailed steam launch owned by Burt Elmer Adams, the bulkheads of Corporation Wharf, and a two-masted schooner tied up at the Tarr and James yard near the saw shed and its steam-operated saw.

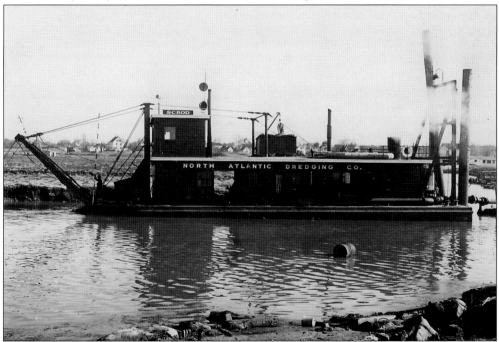

The river has been dredged several times over the years. In 1947, it was undertaken by the *Scrod* of the North Atlantic Dredging Company.

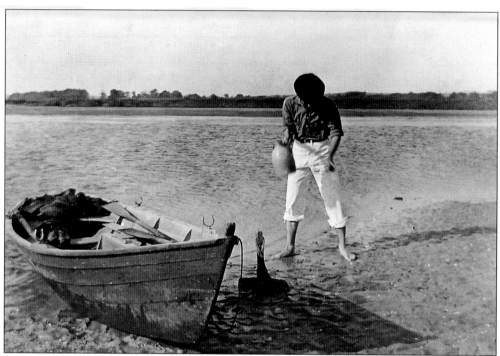

A day spent on the river was and is an Essex tradition. On a sunny weekend, there is a parade of small boats coming from the marinas and boat ramps, headed towards Crane's Beach for a day of relaxation, which may include swimming, sunning, eating, drinking, reading, exploring the beach, and socializing with other boaters. In these photographs, Burton and Mary H. Adams take a downriver outing with friends in the early 1900s.

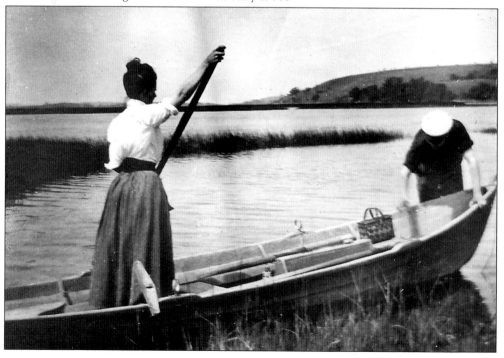

Clay Point has been used by clam diggers for many years. The beach is white with clamshells to a depth of several feet. Behind the beach are several clam shacks. To the right of the white house, which is located at the end of Water Street, is a brickyard. At the far right of this picture is a schooner under construction.

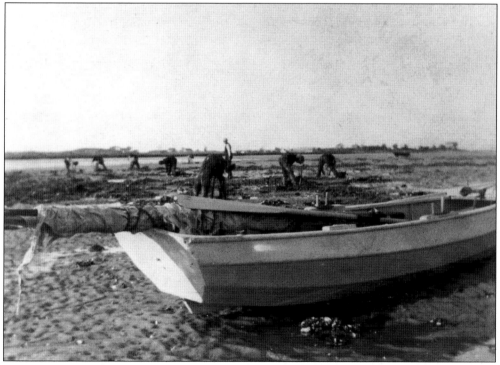

Pictured here are clammers working on the spit back in the 1890s. A typical lapstreak rowboat is in the foreground. This one even carries a mast and sail.

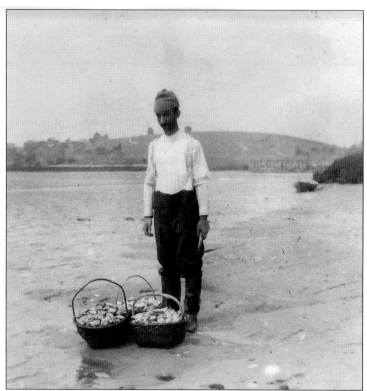

Commercial clamming began in Essex in the early 1800s to supply bait for the Gloucester fishing industry. Essex clams are still highly regarded for their sweet flavor and fetch a good a price in local restaurants. Henry C. Burnham Jr. holds the typical short-handled clam fork he used to dig three pecks of clams out of the mud at low tide.

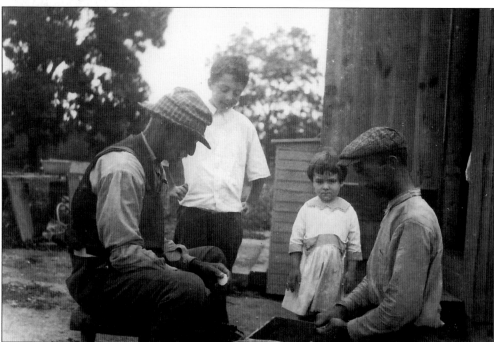

Clam shucking was a family business. H. Clarence Burnham is pictured shucking the day's catch with his son, Henry C. Burnham Jr., while grandchildren, Newell and Victoria, look on. Several restaurants in Essex now specialize in fried clams.

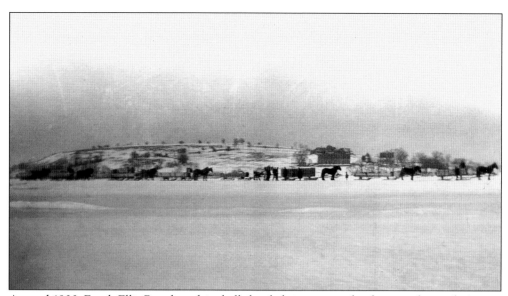

Around 1900, Frank Ellis Burnham hired all the sleds in town to haul material over the ice on the river to build cottages on Hog Island. At that time, the only buildings visible, in this view of a nearly treeless island, are the Choate homestead and barn.

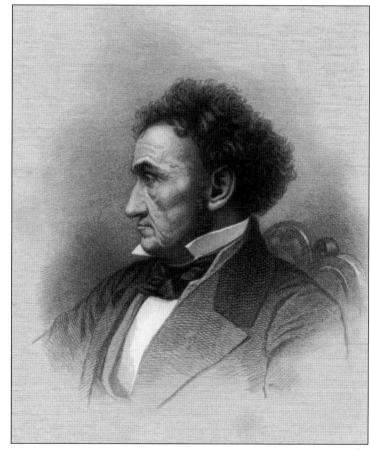

Rufus Choate (1799–1859), a famous orator, lawyer, and U.S. senator from Massachusetts was born on Hog Island in 1799. He served as a Massachusetts senator from 1841 to 1845; both preceded and succeeded in office by Daniel Webster.

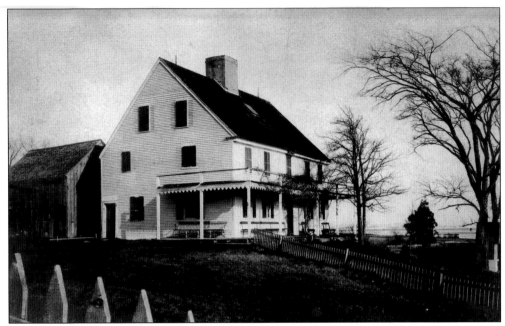

The Choate house on Hog Island was built about 1730 and inhabited by the Choate family for 300 years. At least 82 people named Choate were born on the island. In 1887, the owners of the three farms on the island, namely, Rufus Choate, Nehemiah C. Marshall, and Lamont G. Burnham, changed the name of the island to Choate Island and requested the selectmen to record the new name in the town books.

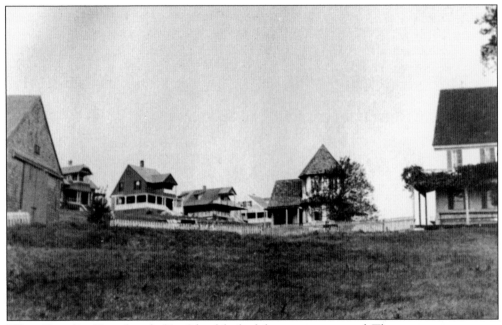

When Cornelius Crane bought Hog Island, he had the cottages removed. These cottages were near the Choate homestead, partially seen at right. For filming of the movie *The Crucible*, a temporary 1690s village was built here. The island, Castle Hill, Crane Wildlife Refuge, and Crane's Beach now form the Trustees of Reservation's Crane Estate.

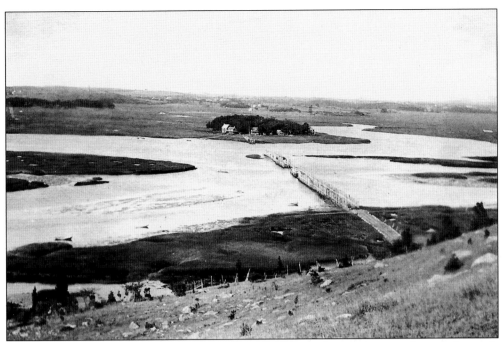

Until 1880, residents and visitors to Hog Island could, at low tide, travel a route through the creek beds out to the island. A bridge to the island was constructed in 1880. The bridge was washed away in the Portland Gale of 1898 and never rebuilt. For some years afterward, the old creek bed was again used to reach the island. Eventually, motorboat service became more convenient, and the roadway was left to deteriorate.

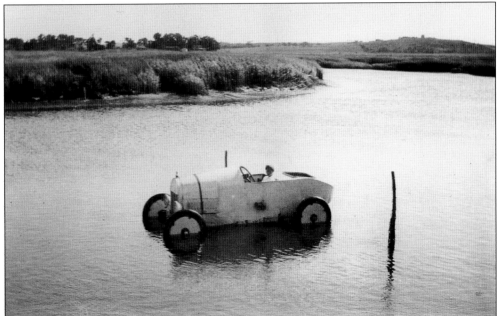

Here Sidney Shurcliff drives down the road to Hog Island in his homemade car in 1923. Poles marked the route through the creeks. Cars entered Hardy's Creek at the end of Island Road. (Courtesy S. Shurcliff.)

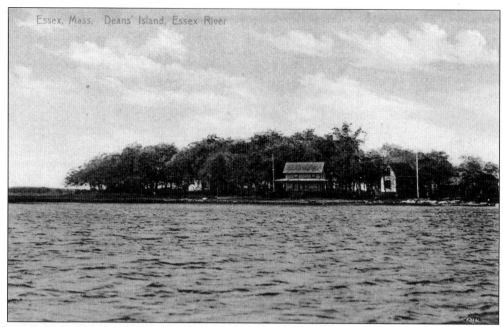

Essex, Mass. Deans' Island, Essex River

When the bridge was in use, the route from Hog Island went to Dean's Island, then to Lowe's Island, and up Wise's Lane to John Wise Avenue.

Agnes Choate Wonson (1883–1981) was a teacher, poet, artist, writer, musician, mother, and wife. She possessed an extraordinary zest for life. Her book, *Downriver: A Memoir of Choate Island,* describes island life during her lifetime.

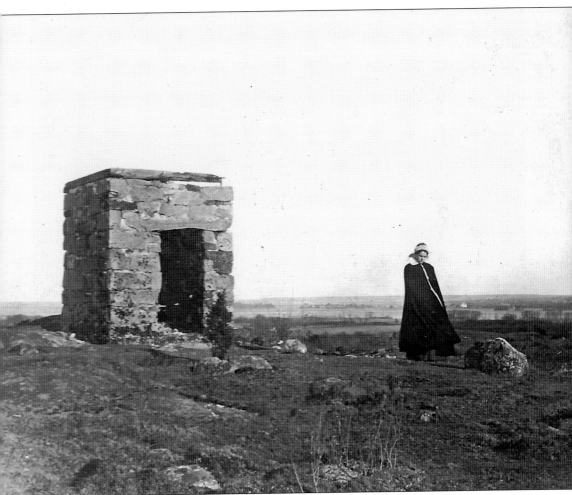

This powder house was built about 1812 by the local militia company for the storage of gunpowder. The militia unit, originally called the Chebacco Light Infantry, updated their name to the Essex Light Infantry in 1826. Mildred (Story) Ellis, wife of Dr. William A. Ellis, stands on Fifteen Tree Hill by the powder house in this early 1900s photograph. The hill has been known as White's Hill, Powder House Hill, Perkins Hill, and finally Fifteen Tree Hill.

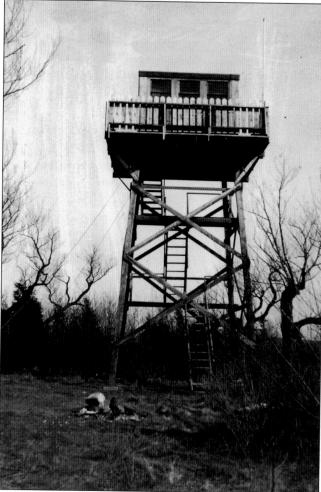

The 15 willow trees on Fifteen Tree Hill were easily visible landmarks when the hill was bare pastureland. This hill was once named White's Hill after the first settler in Chebacco, who built his cabin on the northern slope of the hill. The 1943 U.S. Geological Survey (USGS) topographic map labeled a hill on John Wise Avenue as White's Hill, and this hill "officially" became Fifteen Tree Hill. Coincidently, the new White's Hill also has a stone structure.

An airplane-spotting tower was built on Fifteen Tree Hill in 1942. At first, it was manned by civilian volunteers and later by army personnel who stayed with Harold and Stella Bishop on Western Avenue. A few iron anchoring posts remain in the rock where the tower once stood.

Charles Conrad lived on John Wise Avenue and was known as the strongest man in town. He amazed people by lifting full barrels or large rocks while doing his everyday work. He is pictured in April 1964 at age 86, digging a cesspool by hand and enjoying his cigar.

This Cogswell House was located on John Wise Avenue near the Spring Street Cemetery. Isabella Stewart Gardner, a rich Boston socialite, philanthropist, and world-traveling art collector, is in the car. Her collection is now the Isabella Stewart Gardner Museum. Henry Davis Sleeper (also in the car) was a designer and art collector and his Beauport Mansion is now a Historic New England museum. Here they admire the Cogswell House; some of the paneling from this home is preserved at the Beauport-Sleeper-McCann House in Gloucester. (Courtesy Historic New England.)

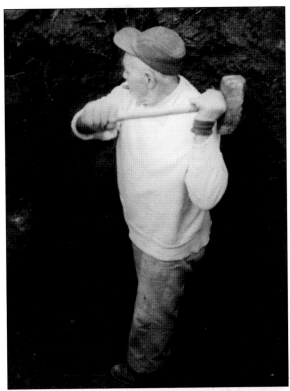

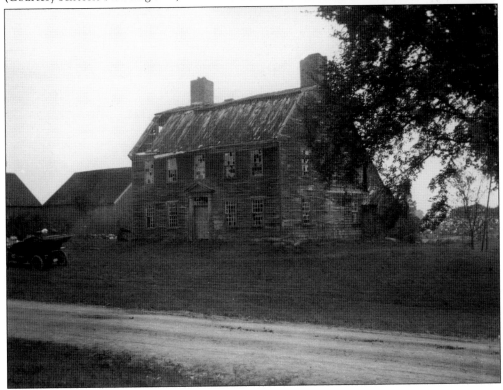

The house behind the trees was built in 1841 to replace an earlier 17th-century house at nearly the same location. The first house was the home of Thomas and Abigail (Proctor) Varney. She was the sister of John Proctor, the witchcraft martyr. She was one of three women who were instrumental in raising the first church building in Chebacco while the men obeyed the order of the court and did not participate.

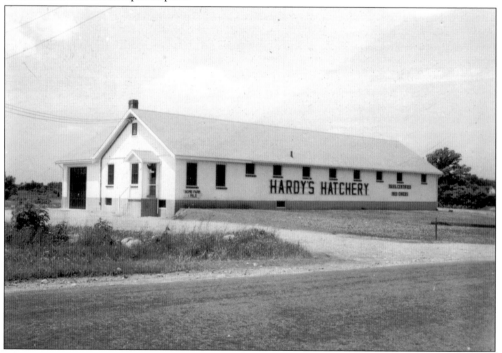

Chicks from Hardy's Hatchery were shipped all over the world. C. Nelson Hardy and his son, Frank, were prominent poultrymen. At one time, Nelson Hardy shipped 10,000 eggs to the British colonies in Africa, and only 41 eggs were cracked upon delivery. He held the highest rating the state inspector could give.

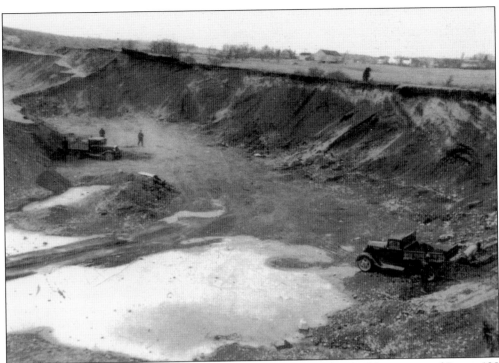

The large gravel pit at the end of Lane's Road supplied gravel to build a section of Route 128 from Beverly to the A. Piatt Andrew Bridge in Gloucester. This pit has since been used to raise oysters.

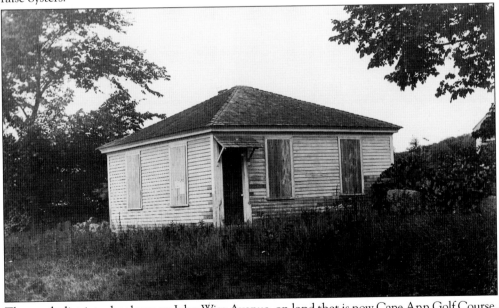

The north district school was on John Wise Avenue, on land that is now Cape Ann Golf Course. The building was moved to Essex Falls, extensively remodeled, and is now a residence. The other school districts with their own schoolhouses were Hog Island, Central, Thompson Island, South, and the Falls, making a total of seven school districts. The one- or two-room neighborhood schoolhouse system continued until transportation became more readily available.

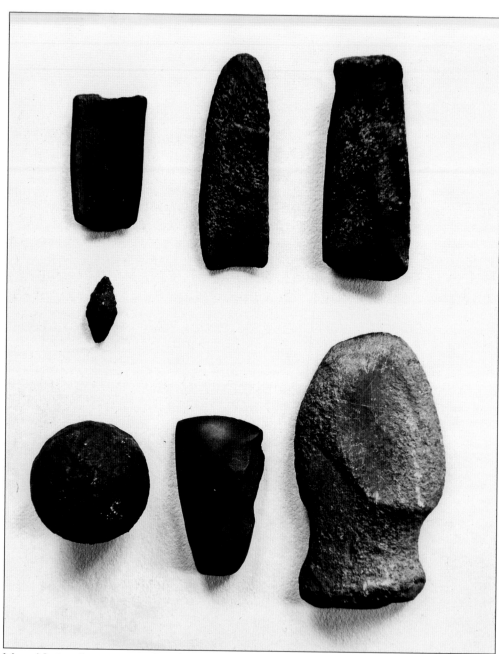

Many Native American artifacts have been found at various places in Essex. In 1810, Moses Andrews was digging a cellar for Thomas M. Burnham and found a stone clearly carved as a man's head. It passed through several collectors' hands and eventually ended up in a Copenhagen museum as an example of Roman art. It is now in the Peabody Essex Museum and is possibly a very important example of early Nordic visitation in the area. Elliot Hardy photographed some of the items found on the Hardy farm, and this image displays a few excellent examples. They include beautifully crafted stone implements and many arrowheads. Also found in a field was an old cannonball, believed by some to have been fired from a British ship that visited the area during the Revolutionary War.

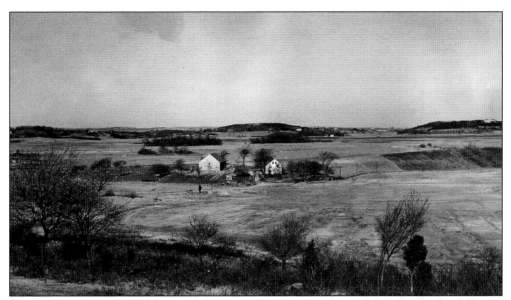

Island Road branches off John Wise Avenue and heads toward Hardy's Creek. This land was the Proctor farm in the 1600s. In this 1939 view, taken from Prospect Hill, one can see the hills in Ipswich, with Tilton hill in the center and Castle Hill at right. Between those hills is Fox Creek. In 1820, the Essex Canal Company was formed to build a half-mile long canal (first proposed in the 1600s) connecting Fox Creek and the Ipswich River with the Essex River.

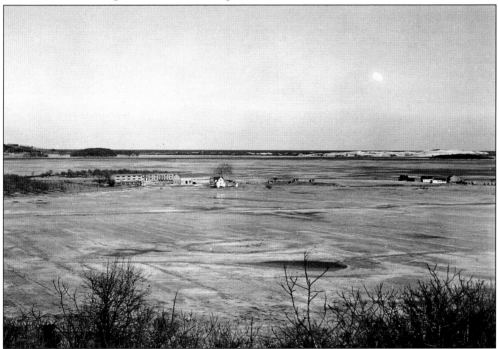

Island Road runs along a piece of upland and salt marsh. Near the end of the road, a portion of the Hardy poultry farm with its hen houses was located. This part of the farm has recently been subdivided and sold off as house lots. At one time, the road continued into Hardy's Creek, to Dean's Island, and then out to Hog Island. That is why it is called Island Road.

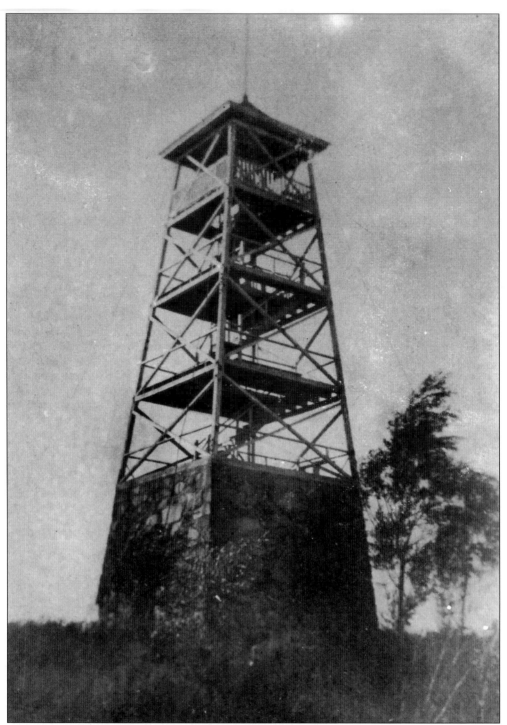

Lamont G. Burnham (1844–1902) had a tower erected on Prospect Hill around 1900 by Epes Sargent. Burnham was a prosperous businessman in Boston, who maintained a summer home in Essex. He benefitted the town in many ways through his gifts. In 1943, the U.S. Geological Survey (USGS) map misidentified this hill as White's Hill, and it is now known as White's Hill.

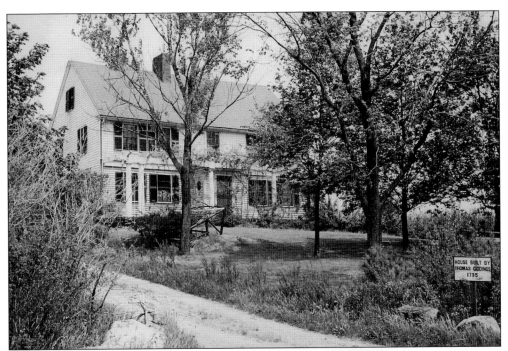

This house at the corner of John Wise Avenue and Island Road was built by Thomas Giddings in 1735. The property eventually passed to his great-granddaughter, Mary Giddings, who married Washington Burnham. Their daughter, Mary, continued to live at the homestead with her husband, Francis F. Andrews. Their son, Lawrence E. Andrews, moved to Gloucester and used the farm as a summer residence. The farm was then sold out of the family.

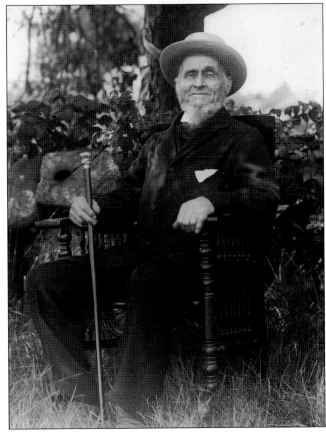

Washington Burnham poses with the Boston Post Cane, which was presented to the oldest resident in town. The *Boston Post* was a popular daily newspaper, and in 1909, it distributed 700 walking canes to towns in New England. The town owned the cane and passed it on as people passed away.

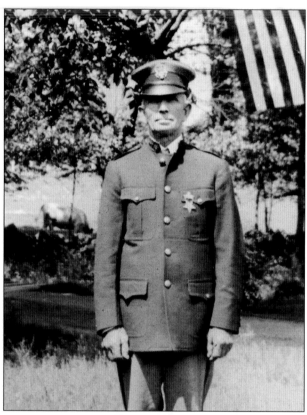

Spanish-American War veterans from Essex were E. Bennett Burnham, Zeno Elwell, and Paul P. Hanson, who all enlisted on April 28, 1898, into the 8th Massachusetts Infantry. Zeno Elwell, seen in his uniform in a 1930 photograph, was a farmer who lived on John Wise Avenue. His mother, Alice (Low) Elwell, was the daughter of Josiah and Elizabeth (Giddings) Low of the North End, which explains why the Elwells happened to settle in that part of town.

David Elwell, with an upturned hat brim, takes a cow in the low-bed wagon from the Falls farm to the North End farm in the mid-1940s. David and his brother, Gilman, were the last of the old-time general farmers in Essex. Their uncle, Joe Elwell, was the very last person to have cows.

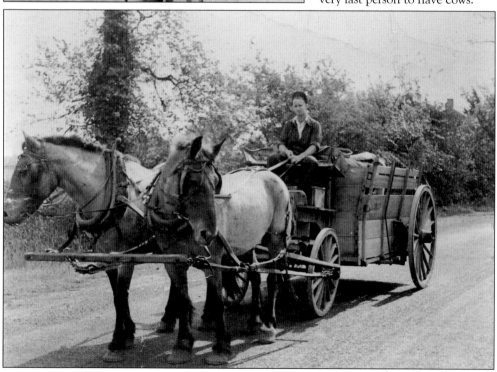

The North End of town is admired for the scenic farmland viewed when coming into Essex from Ipswich. David Elwell is pictured haying his farm.

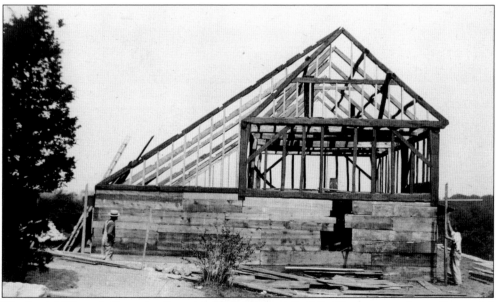

The Beniah Titcomb House is a first period home that was built in Newburyport. It was dismantled and put into storage until Langdon Warner purchased it and erected it on John Wise Avenue around 1915. It has been carefully restored but is not visible from the road. It was placed on the National Register of Historic Places in 1990. (Courtesy Historic New England.)

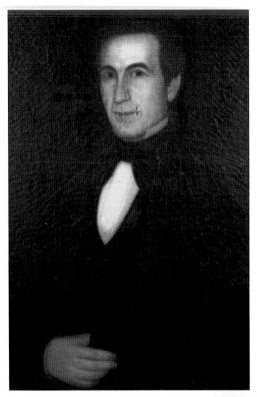

The portraits were created by Alfred J. Wiggin (a Cape Ann artist) for the 1849 marriage of Aaron L. Burnham (1807–1872) and Lucy Cogswell (1813–1879). Tragically, all but one of their children passed away in childhood. Aaron is listed as a carver and gilder, and he was later a justice of the peace and a representative to the state legislature. He was also an early president of the town's Lyceum Society. Formed in 1851, they met regularly in John Burnham's barn in the North End. Its mission was to educate and entertain; they had readings, debates, and hired local orators. The portraits were purchased by the Little couple in Essex in 1935 and are now housed at Cogswell's Grant. (Both, courtesy Historic New England.)

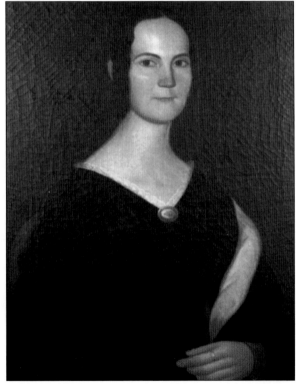

This house on Choate Street was built by John Choate in 1687. Having sheltered five generations of Choates, it passed in 1797 into the hands of William Cogswell. Five generations of Cogswells lived here. When photographed in 1939, George E. Cogswell, the son of Darius Cogswell, owned it. Later Stanley and Rufus Collinson operated Boundary Turkey Farm here.

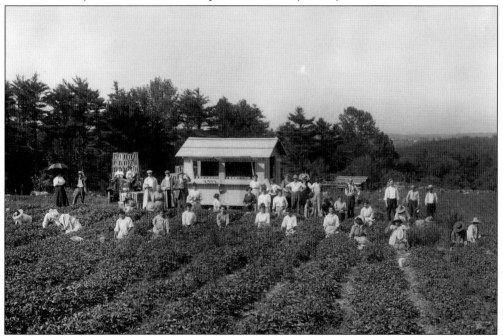

Strawberries and blueberries were commonly raised in Essex for local markets and for the Boston market. A crew is pictured harvesting strawberries on the Henry Ward Andrews farm off Apple Street in 1911. In the late 1920s, strawberries from William Gaffney's farm on Eastern Avenue were reputed to be the first strawberries frozen at Clarence Birdseye's factory in Gloucester.

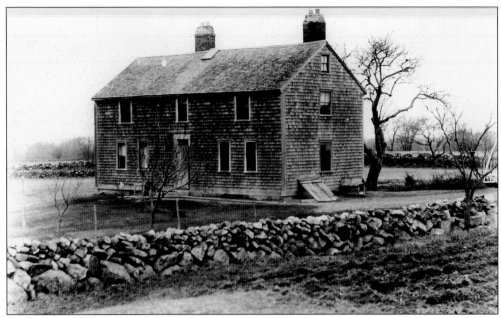

This first period property is known as the George Giddings house and barn. David Low purchased the property from widow Jane Giddings in 1702, and the same Low family then held it for over 200 years. The first four generations were headed by successive David Lows. When the house was photographed in 1913, the owners were D. Choate and Martha F. (Low) Cogswell.

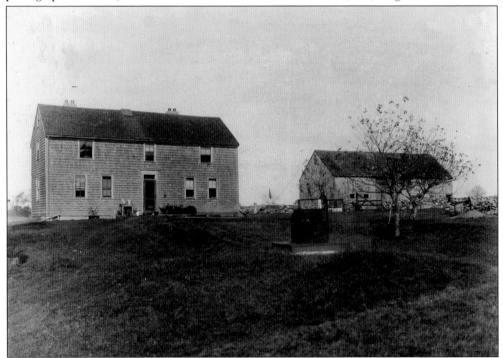

The barn on this property is considered the oldest barn in America in continuous use. The George Giddings house and barn are listed on the National Register of Historic Places. The house has been extensively renovated and no longer resembles the house in this 1913 photograph.

Two

ESSEX FALLS AND CHEBACCO LAKE

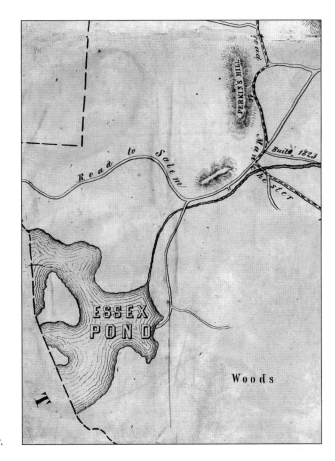

Essex Falls and Chebacco Lake have been well-populated and industrious places ever since a sawmill was built at the Falls in the mid-1600s. This section of David Choate's 1853 Essex map shows with a dotted line the old road from Ipswich to Manchester.

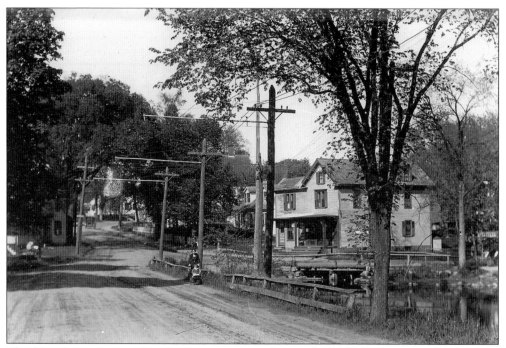

The Alewife Brook, seen above, served many purposes. By the bridge at the end of Apple Street was a watering place where farmers could water their animals or the fire company could obtain water for their pumpers. For many years, the Burnhams and Goodhues operated a bark mill and tanyard upstream toward Pond Street. Located in this neighborhood when photographed around 1920 were the trolley carbarn and power station, a sawmill, a grammar school, a general store, several farms, and many homes.

Neighborhood stores were once popular places for people to gather. Around 1910, a class from the Falls School posed for a photograph on the steps of the Nathan Story store. They are, from left to right, (first row) Ernest Coffill, Oliver Muise, Stuart Cogswell, and Melvin Herron; (second row) Eleanor Jones, Katherine Bannister, and Alice Brown.

The school in this 1880s photograph was built in 1867 by Procter P. Perkins. It was the fourth schoolhouse at the Falls. The first school there was built in 1761 and replaced in 1800. Those schoolhouses were located where Essex Industrial Park Road now begins. The third Falls school was built in 1832 on the opposite side of Western Avenue from the previous schools. When the 1867 two-room schoolhouse opened, there were 112 students in attendance.

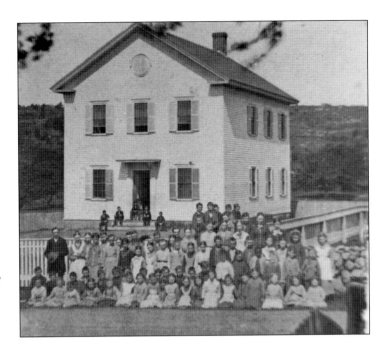

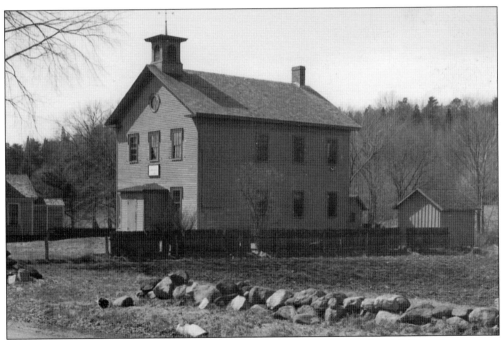

This Falls school closed in 1943, when all the students in town up to the eighth grade were sent to the Rufus Choate School. The congregation of the Universalist Church met here in the late 1940s after a fire destroyed their building. The school is now a private residence and retains its elegant schoolhouse appearance.

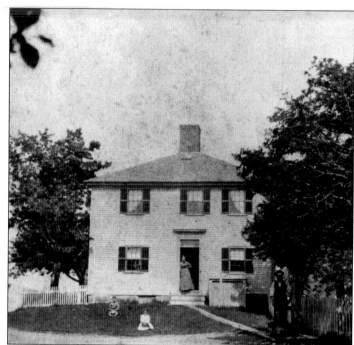

The Michael and Susan Story house is a landmark at the intersection of Western Avenue and Martin Street. In this mid-1870s photograph, nephew Albert "Bert Noah" Story is pictured drawing a bucket of water at the water pump with his children, Edith Abby Story and Harry Story, sitting on the lawn, and widow Susan Story standing in the doorway.

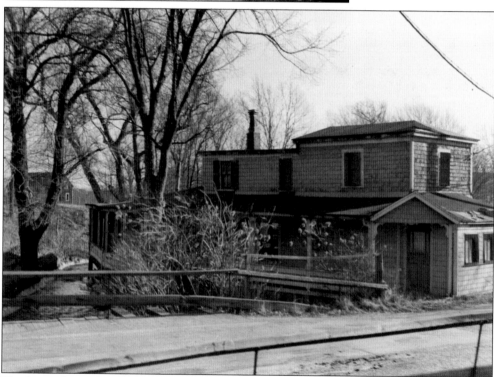

This house, located at the Apple Street Bridge, was built right at the edge of the Alewife Brook. It was torn down about 1939. This photograph was taken from Western Avenue, looking across the bridge downstream. When this house and Nathan Story's store were torn down, the area became much more open, and it is now hard to imagine those buildings occupying that space.

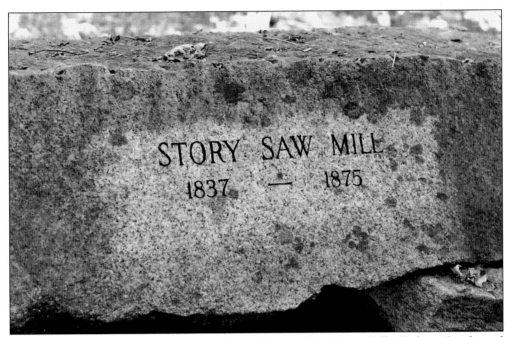

This inscription is found on the ruins of an old sawmill at Essex Falls. Perkins, Jacob, and Jonathan Story owned this water-powered sawmill. Each man brought his own saw with him on his appointed day and worked the mill for his own purposes. A steam-powered mill was built nearby in 1870, and the old mill fell into disuse, eventually collapsing into the Falls. A sawmill still operates in this part of town.

The sign at the turn-off from Western Avenue to Apple Street warns that motor vehicles are excluded from Apple Street. The one available lane on Western Avenue is used by a horse-drawn carriage, which is approaching the camera from the trolley carbarn entrance. This mid-1910 photograph shows the slower pace of that time.

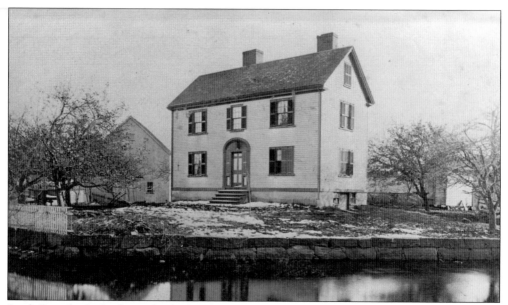

Jacob Story built this house by the brook in 1831. He had a boatyard across Apple Street on the half-moon shaped piece of land along the brook. The many fine boats built there were hauled by oxen around the Falls to the river. After Jacob Story died in 1848, his son, Enoch, occupied the house until his death in 1871 and was followed by son Enoch "Tene" Story.

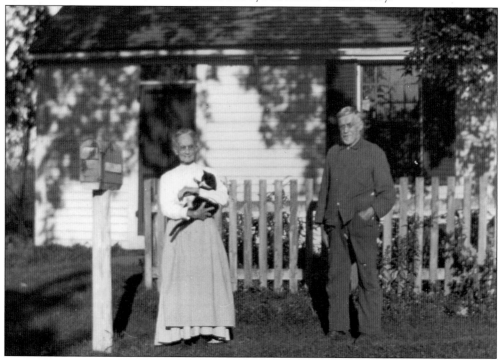

Harlan Page Burnham and his sister, Lucy "Lucy Zack" Burnham, stand in front of their house on Western Avenue. "Miss Lucy" was the general manager and local correspondent for the *Essex Echo* for many years. Page had a cobbler shop and cut hair. Their house was later moved a couple hundred yards down Western Avenue, to a place opposite Walnut Park Avenue.

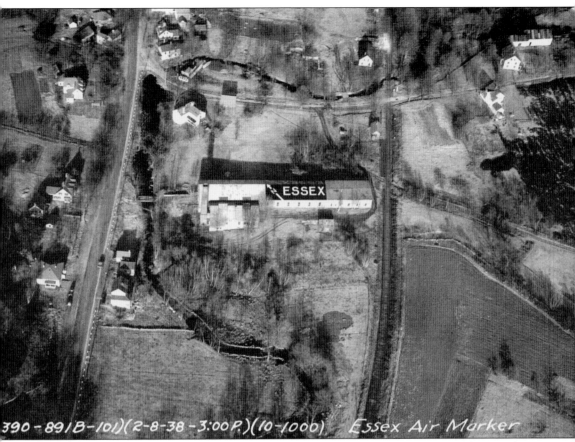

390-89/B-101)(2-8-38-3:00P.)(10-1000) Essex Air Marker

In this 1938 aerial view of Essex Falls, the roof of the trolley carbarn is painted with an arrow pointing north towards the Essex airfield. It was used so aircraft could get their bearings in the air. Also seen are Western Avenue and the Alewife Brook on the left. The railroad track is to the right of the carbarn, and Apple Street runs across the top of the photograph.

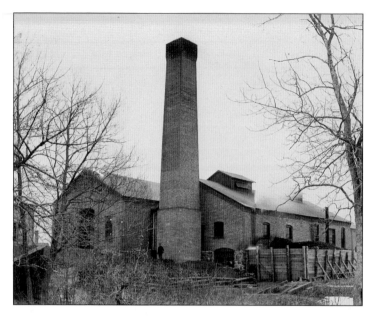

Pictured is the trolley carbarn and powerhouse on Western Avenue at Essex Falls. Trolley service arrived to Essex in August 1895. This was a period of tremendous growth. Just a couple years earlier, Essex had built a new high school, greatly improving educational opportunities for the children in town. A town hall/public library was built according to the style of the time. There was also train service to Boston and elsewhere.

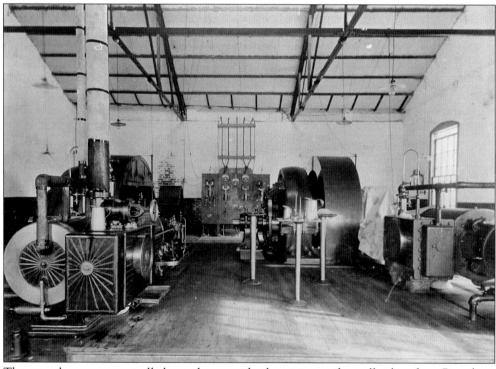

The powerhouse was centrally located to provide electricity on the trolley line from Beverly to Gloucester. In the generator room, there were two engines powered with 100-psi steam, which turned the generators that provided 600 volts to keep the cars running for 25 years. At the rear is a control panel that regulated the line voltage, balanced loads, and protected the generators from overload damage.

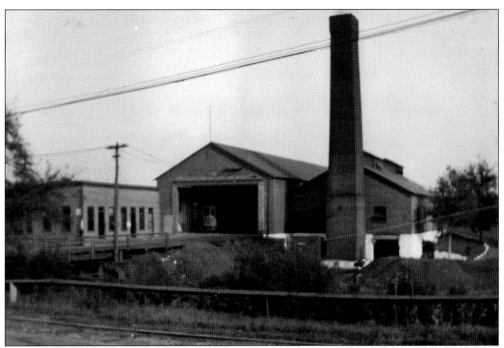

Trolley service lasted until 1920. After several years of lying vacant, the barn was cleaned out, and the old cars were pushed out and burned. The brick building and a few salvaged pieces of rail are all that remain of trolley service in Essex. Under the ownership of Warwick Henderson, the building was converted for use as a woolen mill, later becoming the site of the Industrial Cab Company.

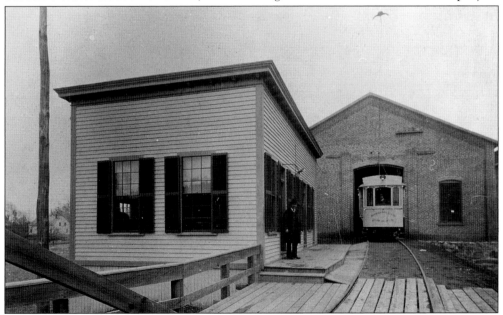

At left is the wood-frame building used by the dispatcher and other officials as their office. The brick carbarn, 44 feet wide and 200 feet long, could house 20 cars. The use of longer, double truck cars and the need for a larger fleet due to increased passenger traffic required the widening of the wood trestle and the barn entrance to include three tracks.

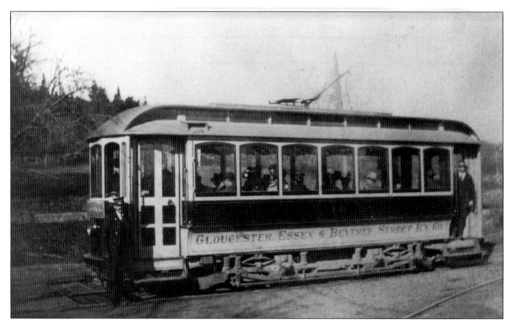

Standing at the left of this Gloucester, Essex, and Beverly Street Railway Company car is motorman William E. P. Taylor. The conductor is unidentified. The car, on its way to Beverly, is just passing the turnout to the carbarn on Western Avenue. The route to Beverly went along what is now County Road and had a siding for Centennial Grove. It met up with the line from Ipswich at Essex Junction in Hamilton.

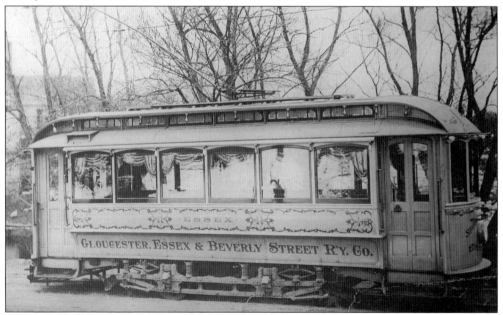

The palace car *Essex*, painted cream and gold, made a festive appearance. The car was put into charter service in 1896 and was specially equipped for parties. Red, white, and blue incandescent lights illuminated its ventilator windows. The interior was of quarter saw oak with velvet cushions and carpets. Embroidered drapes framed the plate-glass windows, and the seats had electric heaters underneath.

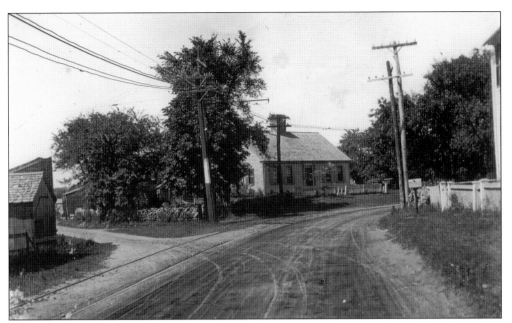

This cape-style house at the corner of Western Avenue and Pond Street was the home of Caleb M. and Jennie (Low) Cogswell in 1910 when the photograph was taken. It was built in 1811 for Philemon Eveleth on the site of a very old house and lands of Philemon Smith. In 1858, Philemon Eveleth sold this property to Daniel Webster Cogswell. Dormers were added to the front of the house, and in the late 1950s, the house was moved to County Road.

A little further down the road from where the train tracks crossed Pond Street, Jimmy's Bridge carried traffic over the Alewife Brook. At one time, people could drive down Pond Street, turn onto Wood Drive by the David Burnham house, and continue around the pond. Part of Wood Drive was on private property, and the road is no longer open to pass through.

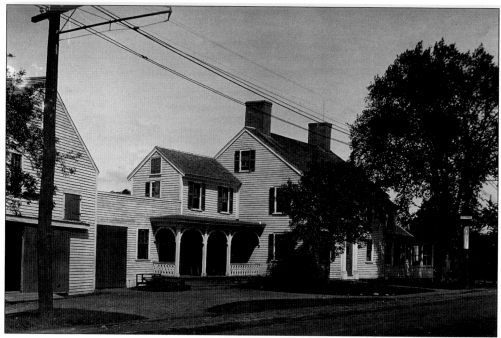

Michael and Nathan Burnham, sons of Westley and Molly (Woodbury) Burnham, built this house on County Road around 1800. Each brother owned half the house, and each had a large family. Everett Burnham, grandson of Michael Burnham, came into possession of the entire property in 1905. It passed to his son, Hervey Story Burnham, who owned it at the time of this 1939 photograph. At this time, it is still held by a member of the Burnham family.

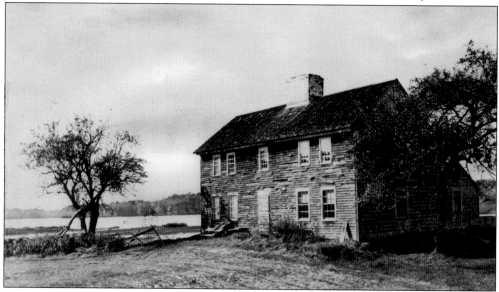

The David Burnham house on Pond Street was built around 1687 and is listed in the National Register of Historic Places. It is also called the Skipper Westley Burnham house, after the locally famous man who was born there in 1747. Westley Burnham was renowned for his seamanship and navigation abilities. He fished on the Great Banks, traded goods in Virginia, was a privateer in the War of 1812, and was an active shipbuilder.

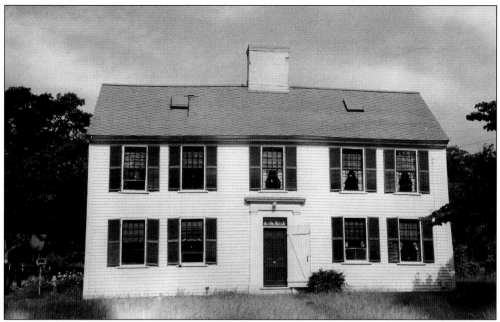

This house on County Road, known as the Madam Eveleth house, was probably built in the early 1700s. During the Revolutionary War, the population of Gloucester experienced a panic due to rumors of British invasion. Among those to flee Gloucester with their valuables was Rev. John Murray and his family, and they were sheltered here. John Murray is known as the founder of the Universalist faith and minister of the first Universalist Church in this country.

This handsome house was built by Daniel Norton before 1810 on County Road near the site of an old Burnham house. His 200-acre farm stretched back through Turf Meadow to the Washington Story farm off Belcher Street. The house passed to Daniel's son, George Norton. He was a noted road builder in his day and is credited with building Winthrop and Pickering Streets, as well as having done construction work in surrounding towns.

David Low owned a large point of land on Chebacco Lake called Lucy's Neck, which he used to pasture sheep and cows and for woodland. With the railroad track running by this property, he agreed to lease it to the railroad for 10 years for recreation use and as a way of increasing railroad business. The park, named Centennial Grove, was opened in 1876 on the 100th anniversary of the county.

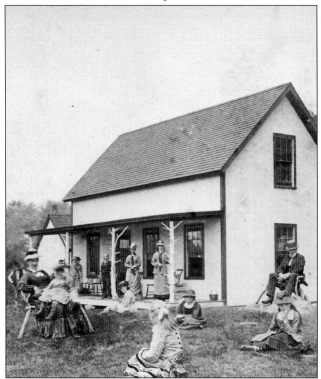

David Low (1825–1903) is pictured sitting beside the first cottage built at Centennial Grove. Centennial Grove was a popular picnic area for business and social groups who would arrive by train from Salem, Lynn, Boston, and other cities. Many of the large picnics filled 20 train cars, but the largest on record required 42 cars and arrived in two sections.

Both Essex and the railroad benefitted from the success of Centennial Grove. The railroad received additional passenger service, and many local people were employed at the Grove or produced supplies for them. A few of the employees seen here standing are, from left to right, Albert Andrews, Homer Riggs, Martha Weston, and Edmund Fuller. The boy sitting in front ran the popcorn stand.

This appears to be a group of Essex residents enjoying a day at Centennial Grove. They are, from left to right, (kneeling) Eugene Callahan; (standing) Lawrence Story, Edith Riggs, Lily Taylor, Nellie Andrews, Carolyn Cook, Mrs. Lewis Story, Lessie Burnham, and W. E. P. Taylor.

The railroad arranged everything for people traveling to Centennial Grove. Transportation, meals in a large dining room, playground areas, a dance hall, rowboats for hire, and a shooting gallery off to one side were provided.

When the railroad lease for Centennial Grove expired in 1886, David Low carried on the operation of the picnic facilities with the help of his family members and friends. Regular meals were served in addition to the store and game facilities. The town of Essex now owns the property, and it is a public recreation area. In 2009, this site was used to film the Adam Sandler movie *Grown Ups*.

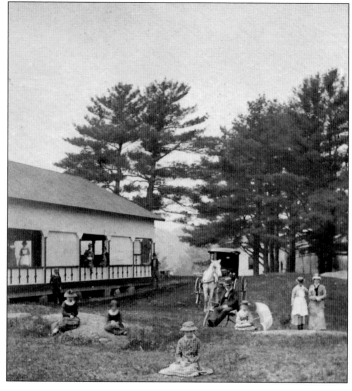

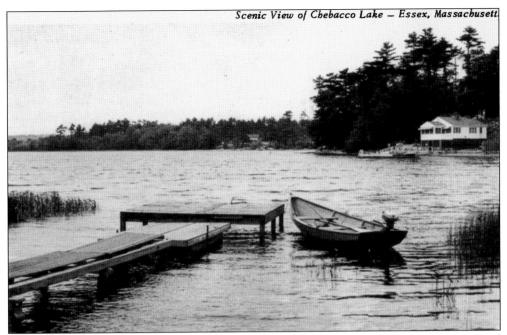

Across the lake and to the right is Gregory Island. It was originally an island, but it is now connected to Hamilton by a man-made neck of land. In 1910, there were two summer camps there, one owned by N. Burnham and the other by M. Story. Gregory Island was subdivided into a number of lots for use as cottages, most of which have become pleasant year-round homes.

The Salem Cadets had an annual encampment at Centennial Grove for several years. There was a large parade ground for their use as a training field. Their stay at the Grove brought many people from town to watch them drilling and listen to their marching band. During Cadet Week, the most popular attraction was Governor's Day, which attracted crowds of people for the festivities.

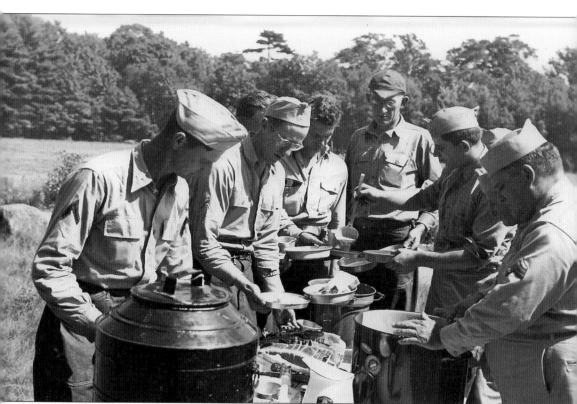

During World War II, the Grove was used as a camp for the 13th Company, 24th Infantry, Massachusetts State Guard. Here at chow are, from left to right, Fred Bragdon, Charlie Humphries, Ray Chapman, Fred Doucette, Dave Wood, Ted Melanson, Harvey Cook (front), and Lawrence Shanks (behind at far right).

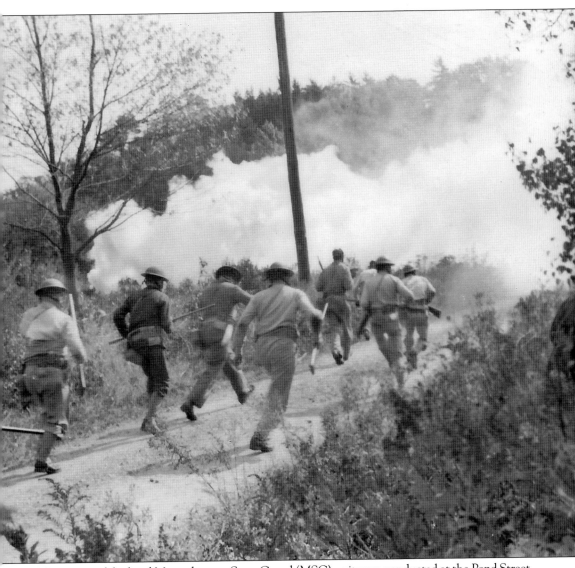

Maneuvers of the local Massachusetts State Guard (MSG) unit were conducted at the Pond Street farm of Major Russell, MSG. Military struggles were never far out of mind; Essex residents were involved in all major U.S. conflicts. Essex sent men to several struggles with Native Americans throughout the 17th century, including the Pequot War and King Phillip's War. Several more battles with Native Americans included Essex men in the 1700s, up to the French and Indian War in 1754. Essex men were even included in battle against the Spanish in the Spanish West Indies. At least 100 men fought in the Revolutionary War, many served in the War of 1812, at least 200 went to the Civil War (some fought at Gettysburg), and many served in both world wars.

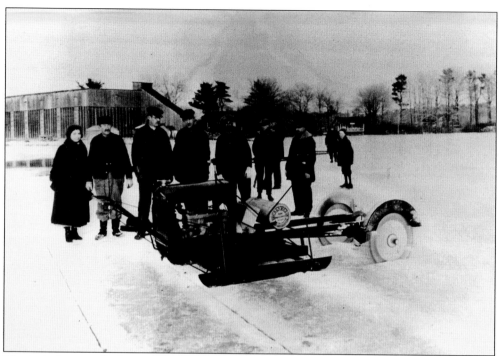

The ice industry at Chebacco Lake brought the railroad to Essex. When the ice was 10 inches thick, ice harvesting could begin. The ice was first grooved in a checkerboard pattern. The old grooving method used a 5-foot saw pulled by a horse to cut down two-thirds of the depth. A breaking bar separated off single cakes. In the 1924 photograph above, Charles W. Mears poses with his crew and a new motorized grooving machine. Standing behind the grooving machine are, from left to right, a customer, Charles W. Mears, William Tebo, Charles Berry, George Towne, John Wilson, Willard Andrews, and Bertram Mears. James Hoskins is the boy skating, and Billy Hubbard is in the far background. (Both, courtesy of the Sherman Mears collection; Essex Shipbuilding Museum.)

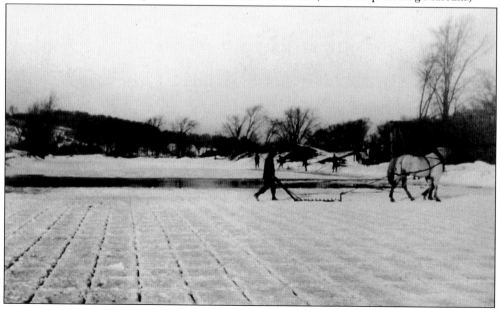

Three

SOUTH, EAST, AND CONOMO POINT

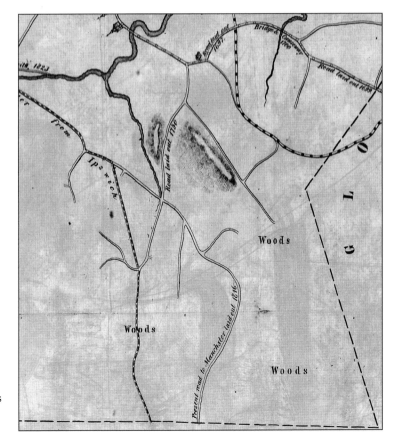

Much of South Essex was subject to a grammar school tax to be paid to the Ipswich feoffees. In 1651, a large tract of land was leased to John Cogswell, and residents of that land paid a small tax for the next 260 years. In fact, the payments continued for almost a 100 years after Essex separated from Ipswich.

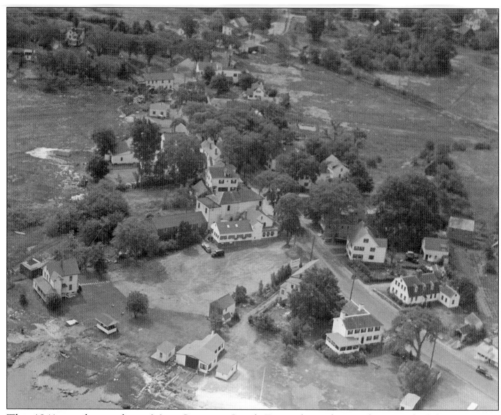

This 1941 aerial view shows Main Street in South Essex, from the southern end of the causeway to the intersection of Main Street, Eastern Avenue, and Southern Avenue. Along the waterfront were several shipyards. Just beyond the open space was Kenneth Woods's restaurant, the Captain's Table, and the Knights of Pythias Castle Hall.

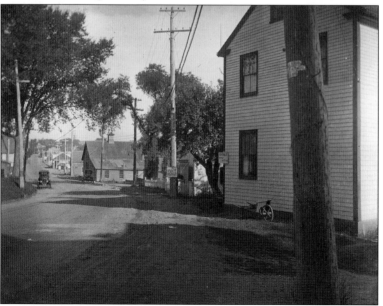

The building at left with a "For Sale" sign is now Howard's Flying Dragon antique shop on Main Street at the south end of the causeway. The sign on the telephone pole warns drivers to go slowly and that they travel at their own risk. The next building is labeled "Col J. Low's Hotel" in an 1830 map of Essex.

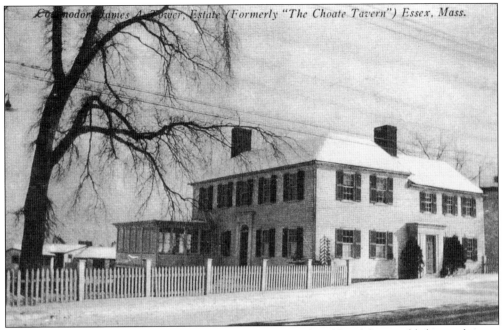

This building, formerly the Choate Tavern, has been a bed and breakfast establishment known as the George A. Fuller House since 1988. George Fuller was the son of S. B. Fuller, who built the shoe factory on Southern Avenue. George Fuller married Lucy Burnham in 1879. The daughter of Aaron and Lucy (Cogswell) Burnham, she grew up in that house.

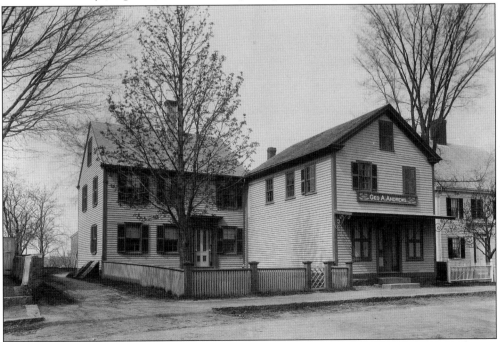

George A. Andrews, son of Timothy and Mary (Andrews) Andrews, was born in 1847. He was the proprietor of this store on Main Street in South Essex in the late 1800s. He died before 1900. The building, seen in the next two photographs, is now at Burnham's Corner.

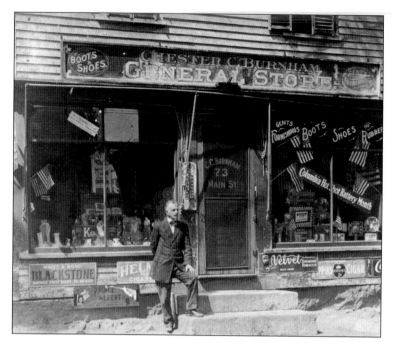

Chester C. Burnham stands in front of his general store on Main Street in South Essex. He had worked with his father, George Frank Burnham, at "the Old Stand on the Causeway." That store burned down in 1896. Previously this store had been under the proprietorship of George A. Andrews.

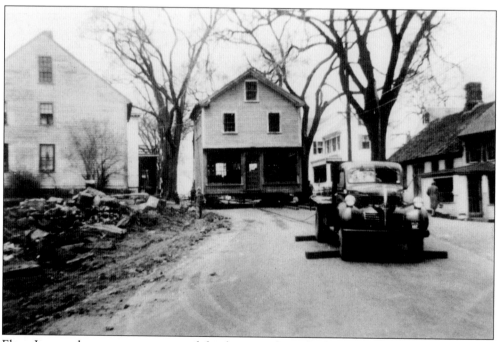

Elton Low took over management of this business from C. C. Burnham in 1931. He moved the building down to Burnham's Corner in May 1947, where he operated it as an Independent Grocers Alliance store (IGA). In 1962, the store was sold to Richdale. It is now occupied by Prado Antiques.

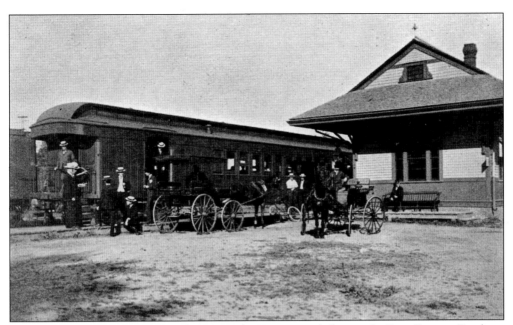

The Essex branch of the Boston and Maine Railway was extended across the Essex River to Southern Avenue in South Essex in fall 1887. The *Boston Daily Globe* noted the enthusiastic celebrations marking the occasion. Hundreds celebrated with feasts, bonfires, cannons, and fireworks. After train service to South Essex ceased in 1926, the building was sold and converted to the Wishing Gate Barbershop. It is now a private residence.

The intersection of Main Street, Southern Avenue, and Eastern Avenue is known as Burnham's Corner, or Joshua's Corner after Joshua Burnham, who lived in a house located behind where the photographer would have stood for this photograph.

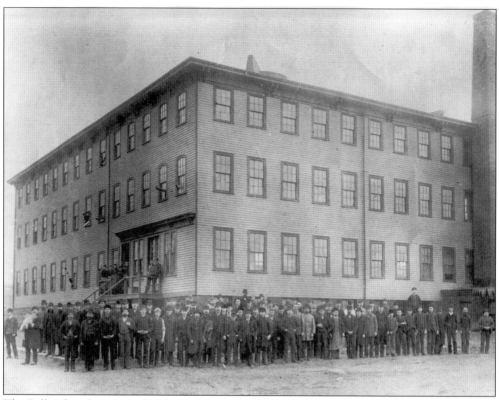

The Fuller shoe factory on Southern Avenue was built in 1872 and became the largest employer in Essex during the 1870s and 1880s. The railroad line was extended across the Essex River to Conomo Station principally because of the additional freight business provided by this factory. A spur track ran between S. B. Fuller's two factories (Fuller's Box Factory was on the other side). The business closed by 1909.

Noah's Hill is located off Addison Street and abuts the marsh, south of the causeway. In this photograph taken by Burton A. Adams around 1900, a woman looks towards Conomo Station. The railroad trestle is visible on the left.

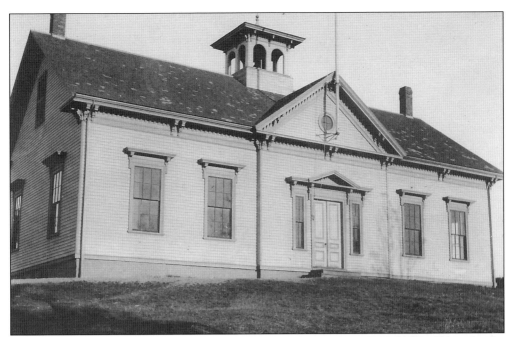

The Thompson Island School closed in 1942. The Essex Veterans of World War II bought the property from the town, and it became known as the AmVets Hall. After the local chapter disbanded, it was converted to a private residence.

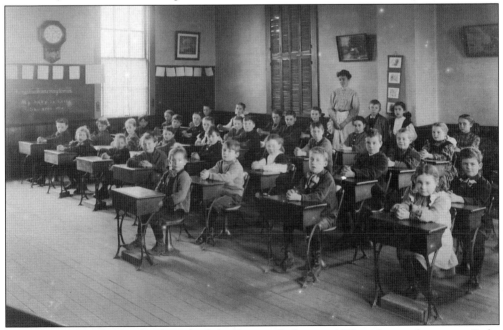

The Thompson Island School was built by Proctor Perkins in 1872 with two classrooms. Ruby M. Adams was the teacher there from 1902 to 1914. She is standing at the back of the classroom in this 1908 photograph. In 1923, the seventh and eighth grade students were sent to the high school to benefit from the program offered there. The school then only had grades one through six, allowing each teacher to have three grades, rather than four.

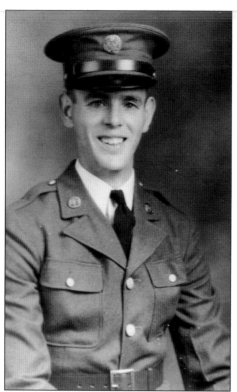

The Essex AmVets post was named after Herbert Goodhue, who died at Bataan on May 13, 1942. He was the son of Walter C. and Myrtle D. Goodhue and was the only Essex man killed in action during World War II.

Grace E. (Jenkins) Foss poses with the Boston Post Cane on October 30, 1990, at age 100. She was very active and wrote *Memoirs of an Octogenarian* about her life in Essex. She died at 100 and was the last person to hold the cane. The cane is now at the Essex Shipbuilding Museum.

Sarah Noble, who was married to Frank Noble, managed the Elm Tree Tearoom on Southern Avenue from at least 1930 to 1941. She was a magnificent cook, known as one of the greatest in a town of many accomplished cooks.

Helen Moreland lived to be over 100 years old. She was born in 1883. She is pictured visiting with her neighbors and friends in 1978. They are, from left to right, Lydia Dodge, Evelyn Knowlton, and Helen Moreland.

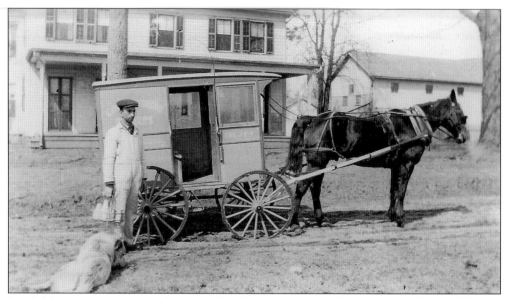

Local delivery was once a part of everyday life. During the early milk routes, the milkman delivered fresh milk every day, and he poured it into containers provided by his customers. Besides the delivery of fresh milk, baked goods, meat, eggs, fish, and fruits, other purveyors of perishable goods had regular routes through Essex. Dry goods and other more durable products were sold in neighborhood stores.

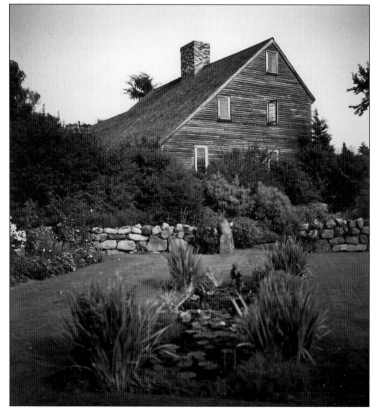

This saltbox-style house was built in 1690 as an Andrews homestead. In the 1850s, it was the home of Miles and Elihu Andrews, sons of Elias and Martha (Lufkin) Andrews. The two brothers split the farm in 1868, with Miles occupying the old homestead until his death in 1888. Later it was home for the families of Walter Stowe (1888–1931) and John Bethell (1931–1970).

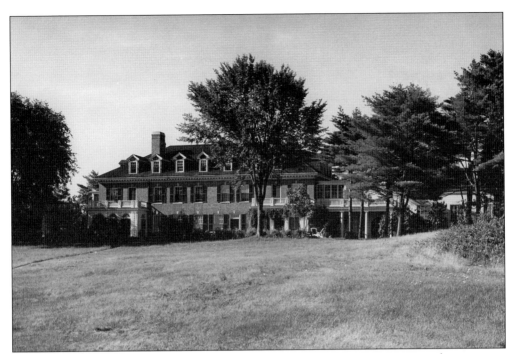

The S. D. Warren estate, which was built on Apple Street in 1905 as a summer residence, is seen in this 1939 Elliott Hardy photograph. The house is one of the few brick buildings in town and the only brick residence. Recently it was owned by a member of a popular rock music band.

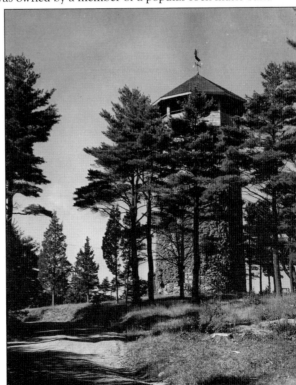

Among the interesting features on the property is a water tower. It is one of three stone structures in Essex that sits atop hills; the others being on Fifteen Tree Hill and White's Hill. Steel towers in town include a fire tower on Southern Avenue and a couple of cell towers.

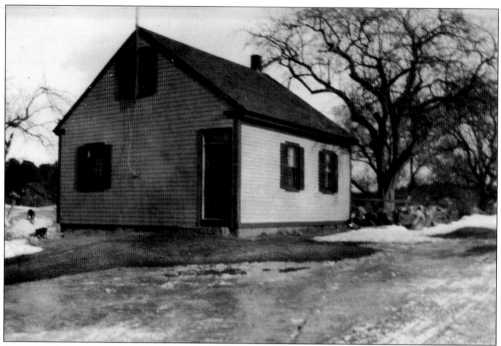

Rocky Hill School, also called South District School, was located on Southern Avenue, across from Apple Street. Among the teachers there was Ruby Adams, who taught from 1899 to 1902. The building is now a garage at Bothways Farm.

Bishop's Grave is in the Chebacco Woods on land now protected by the Manchester Essex Conservation Trust. Mr. Bishop was walking from Essex to Manchester, when he got lost during a snowstorm in 1770. He was buried where he was found in the spring.

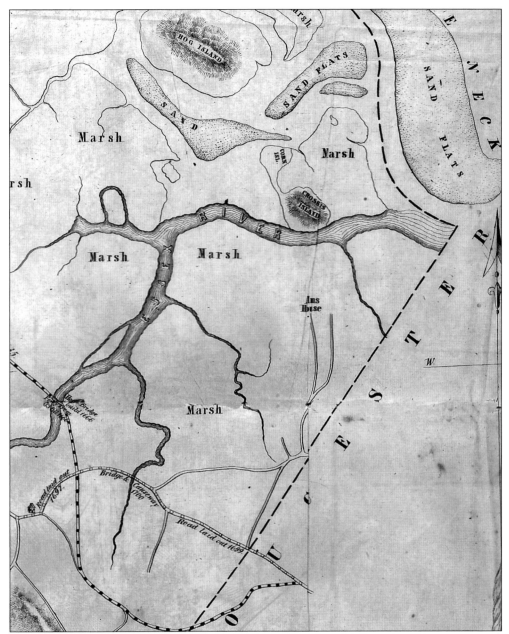

In this section of David Choate's 1853 Essex map, the dotted road follows the 17th-century route to Gloucester. It crossed the Essex River at a place where the upland on either side of the river was most narrow. Today Historic New England's Cogswell's Grant is on the west bank of the river, and the Greenbelt Association's Allyn Cox Reservation is on the east side. The 1853 map also shows Lufkin Street, Lufkin Point Road, Harlow Street, and Conomo Point Road ending at the almshouse.

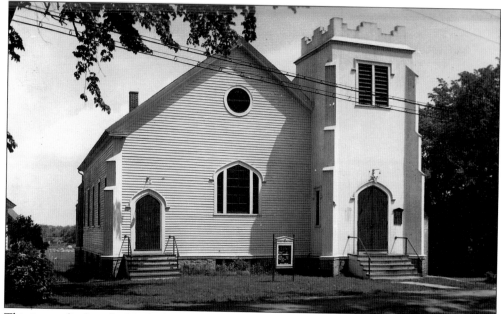

This image displays the Methodist church's distinctive architecture, but the building started as a small unadorned structure. The Methodist community first took hold here in 1809, and one of the first ministers, Elias Smith, printed what many believe to be the world's first religious newspaper. The church was first known as the Christian Society and officially adopted "Methodist" in 1874.

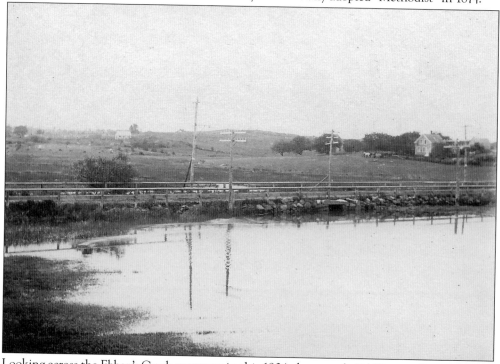

Looking across the Ebben's Creek causeway in this 1904 photograph, Ed Diamond's team is seen proceeding up a lane to his piggery field located behind an orchard and Henry C. Burnham's barn. In the distance on Issacher's Hill, the cow pasture is bare of trees.

One of the most picturesque places in Essex is Burnham's house on the marsh. The house was Ebenezer Burnham's boat shop. He built vessels there and launched them into the creek. The creek used to wind around by the right-hand shore, so Ebenezer dug a straight canal for his boats to get to the river easier. The 1945 USGS topographic map spelled the name of the creek "Ebben's Creek," and so it is still called today, even though the name was previously never spelled that way.

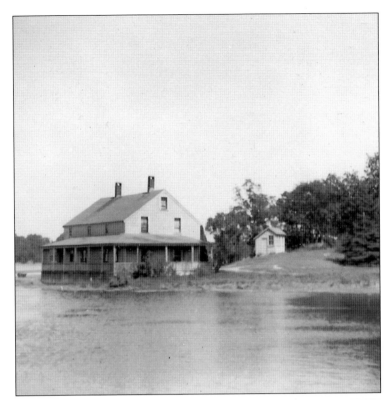

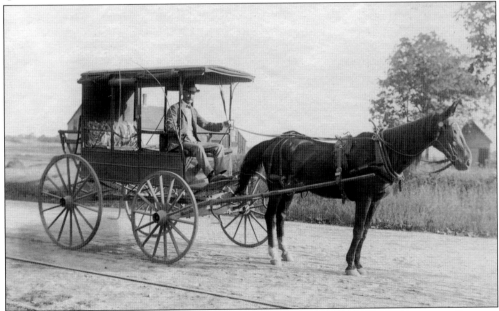

David Corcoran ran a passenger service from Conomo Station on Southern Avenue to Conomo Point. This picture was taken near Ebben's Creek. His wife's brother, David L. Haskell, lived nearby in a house that later became the Hearthside Restaurant and the Windward Grill. His daughter, Mary, married Thomas Spittle and lived in a house on the south side of the road where Corcoran is pictured and where he is facing.

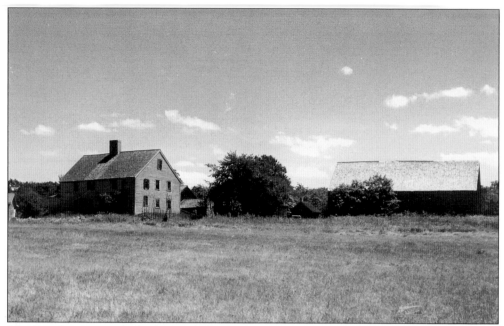

John Burnham received a land grant for his participation in the Pequot War. His house was built in the mid-1660s by Ebben's Creek. The house remained in the Burnham family for many generations and then passed on to the Haskell family, and around 1900, it was bought by William Gaffney.

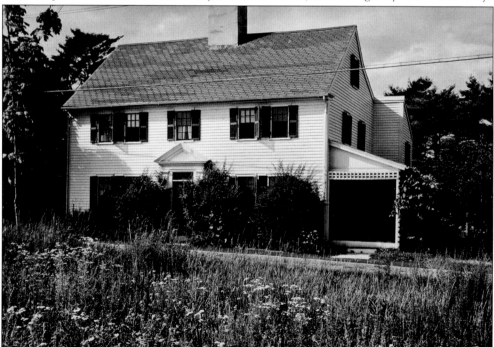

Many generations of Burnhams farmed the land around this 1697 house. For over 200 years, this Burnham house was the only house on Eastern Avenue between the John Burnham house at Ebben's Creek and the Gloucester line. The next house on that stretch of road was built around 1900 across the street and a little towards Essex center. It is now the home of Essex Seafood.

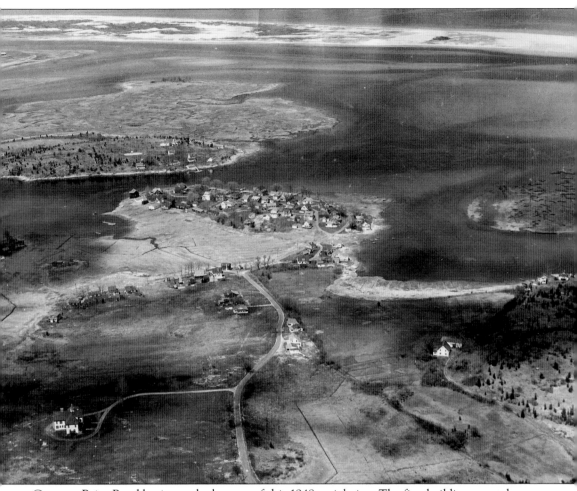

Conomo Point Road begins at the bottom of this 1948 aerial view. The first building seen when headed to the Conomo Point is the former poor farm off to the left. By 1948, the associated barns had been demolished. Continuing down the road, the cottages are located on the road leading to Robbins Island at left. A cluster of cottages still forms a summer community at Conomo Point. Beyond the Point is the Essex River and Cross Island. Dilly Island, once called Daffe Adown Dilly, is a small wooded island separated from Cross Island by marshland. The barrier beach protecting the Essex estuary from ocean surf is Crane's Beach.

In 1825, the Essex townspeople bought Capt. John Proctor's farm to care for the poor. The farm contained about 100 acres of upland, 50 acres of marsh, and 20 acres of woodland. An almshouse, seen in this 1880s photograph, was built in 1834 to house the residents. This building became inadequate by 1900, and a new substantial residence was built a couple years later.

The farm buildings at the poor farm are pictured at left in this 1895 view of the road to Conomo Point. It is amazing to see this area without trees, as it is now wooded over and this view is not possible today.

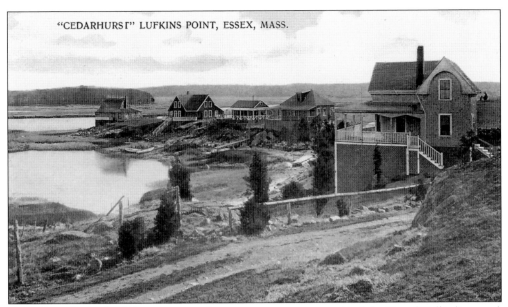

"Cedarhurst" at Lufkin's Point contained summer cottages managed by John E. and Nellie (Lamson) Lufkin. They lived in an old house off Lufkin Point Road. The cottages on Walker Creek have been replaced by a number of fine homes in this quiet part of Essex.

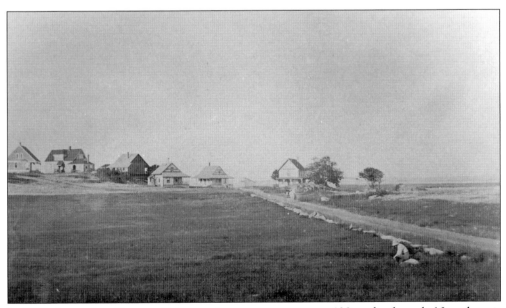

In 1895, the road to Conomo Point was just a causeway across 100 yards of marsh. Now there is a town boat ramp and beach area where Walker Creek nears the roadway on the right side of this photograph.

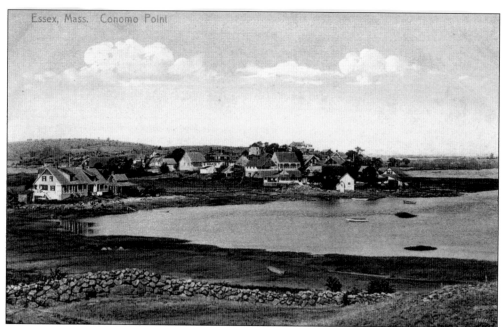

This view of Conomo Point, probably taken in the mid-1910s from what is now Ralston Drive, shows a couple of cottages at left, then an open space, which is a public beach and boat landing, and then the point itself. Hog Island is in the background.

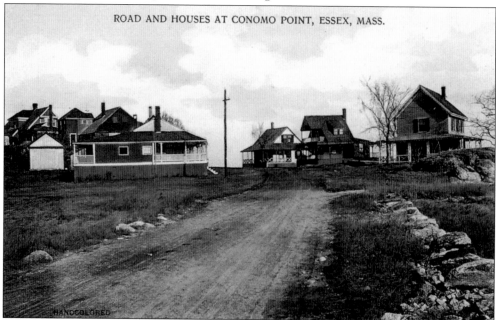

ROAD AND HOUSES AT CONOMO POINT, ESSEX, MASS.

The Conomo Point area includes the land off Conomo Point Road where the former almshouse is located, Robbins Island, and the point itself. This town-owned land—called Town Farm Point until the named was changed in 1883—has been rented to people for their use since 1875. Originally, it was populated with hunting and fishing camps. Eventually the shanties became summer cottages, and Conomo Point developed into a close-knit community. Each tenant worked in association with others to benefit all who spent many pleasant summers there.

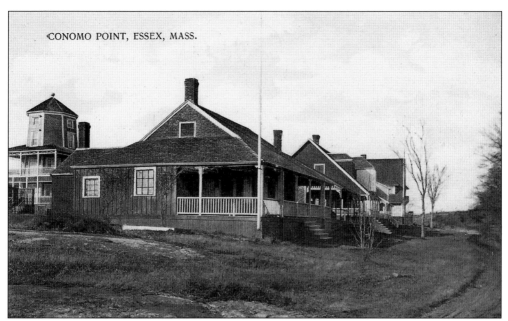

The octagonal cottage known as the Lighthouse was built in 1896. In order to have an unobstructed view of the water and sand dunes, a second-story piazza extended around the house. It is considered a landmark. The roadway at right goes along the waterfront to the tip of Conomo Point.

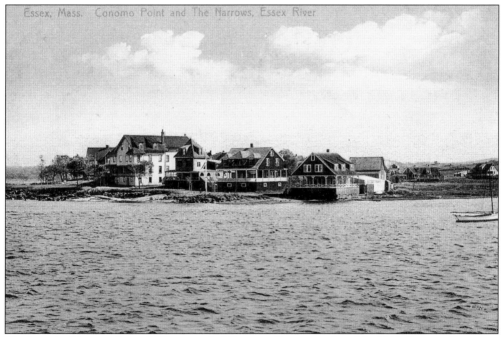

Essex, Mass. Conomo Point and The Narrows, Essex River

The large building in this c. 1905 postcard of Conomo Point was a hotel. In 1915, Conomo Point was hit by a severe fire, which destroyed five houses and the hotel. While it was in operation, Conomo Hotel was a popular resort for driving parties in search of good chicken and lobster dinners. At the seasonal closing of the hotel, a sea serpent even made an appearance at "the Narrows."

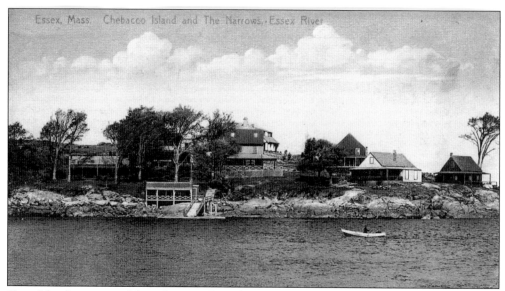

Cross Island is separated from Conomo Point by a piece of the Essex River called the Narrows. It is privately owned. Robert Cross obtained possession of the island and surrounding land in 1654. A veteran of the Pequot War, Cross owned land down to John Burnham's land grant. The first summer resident, Philip Southwick, constructed a small building there in 1835. The owners of Cross Island saw the possibilities and erected several cottages over the years.

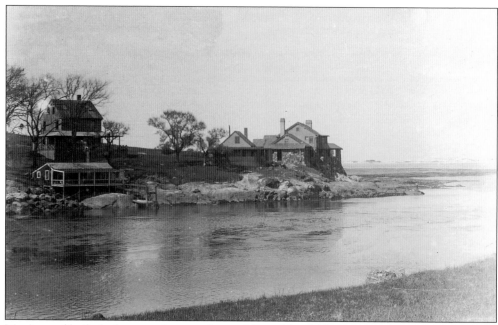

Mr. Atwood built the house at the easterly tip of Cross Island. He was related to the Abbotts, part owners of the island. After a few years, he had the house taken down and relocated to Gloucester, where it was rebuilt. It has been reported that this was caused by a dispute among the residents. Today only the stone foundation and part of a chimney remain to mark the event.

Four

MAIN STREET

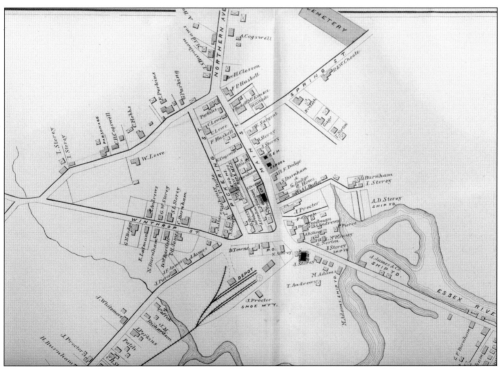

The causeway and Main Street are the backbone of the bustling town. This clipping from an 1884 map shows Essex center and part of the causeway. Indicated in the center are Spring Street Cemetery, the old burying ground, central schoolhouse, Congregational church, the fire engine house on Pickering Street, and the ropewalk. In the square are the homes of Dr. Woodman, N. Story, and A. D. Story, and the Universalist church. Moses Adams's shipyard is above the bridge, and the shipyards of J. Story, A. D. Story, and J. James and Company are shown around the river basin.

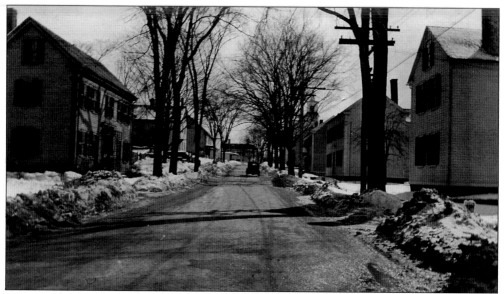

Here is Main Street near Spring Street in February 1934. This part of town was built up in the 1830s, though the back part of the house at left was built by John Cavies in 1724. Just before the revolution, his son, Nathaniel, built the front part. The house was remodeled in 1882 by Sarah (Boyd) Griggs, a descendant of John Cavies.

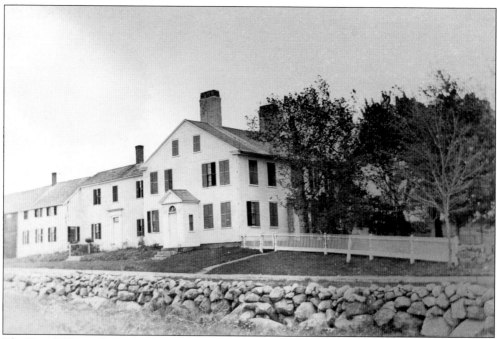

The David Choate house on Spring Street was built in 1803 at the site of the old Adam Cogswell house in which Rev. John Cleaveland, third pastor of the Congregational Church, lived for many years. Rev. Robert and Hannah Crowell lived here for their married life. Hannah was the daughter of David and Miriam Choate. Reverend Crowell was the seventh pastor of the Congregational Church and a historian of Essex.

Rufus Choate was born in 1834, a nephew and namesake of the famous orator, politician, and statesman, Rufus Choate. Rufus Choate was a farmer, operating the farm at the family homesteads on Spring Street and Hog Island. Choate was described by Dana Story as the greatest Essex historian. The town is greatly indebted to him for all his historical writings.

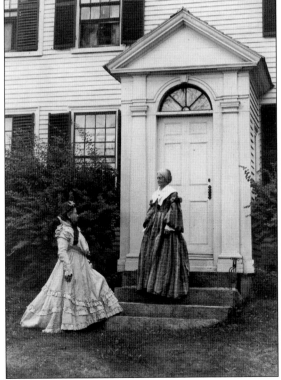

In August 1930, Thurza Stanwood and Augusta Story were pictured at the Choate house on Spring Street. As a part of the tercentenary, there were open houses at several homes in Essex. Mary Lyon visited this house in 1830. She was a teacher at Ipswich Female Seminary and founder of Mount Holyoke College. She consulted with deacon David Choate about theories of education.

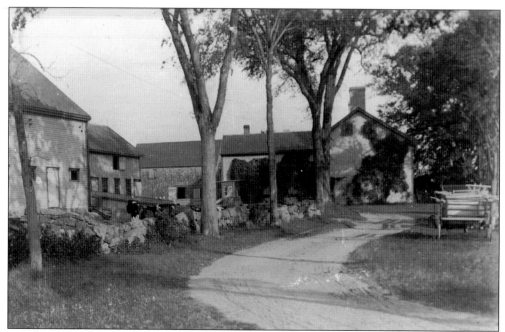

Cogswell's Grant is the name now given to the lovely 165-acre farm owned by Historic New England. This property was granted to John Cogswell in 1636. His great grandson, Jonathan, built the house presently located on the property around 1732. It was owned by the Adam Boyd family from 1839 to 1927. Bertram and Nina Little bought it in 1937, and ever since, it has served as a setting for their collection of New England folk art.

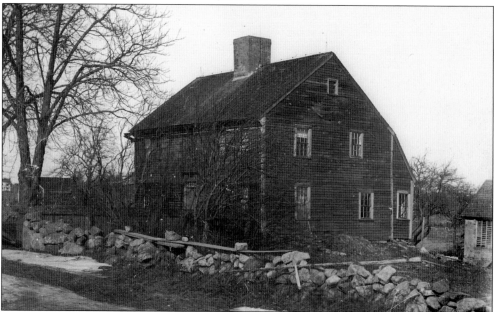

This first period house was built by John Cogswell as a replacement to the original 1636 cabin. Thomas Choate, with sons Jeremiah and Stephen, moved off Hog Island around 1750 and purchased this farm. It was occupied by their descendents for 135 years and was later Charles Patch's farm. The house was demolished around 1910.

Hannah Choate (1739–1785) was born on Hog Island, and soon after, the family moved to a farm on the mainland. Rev. John Cleaveland introduced her to the prestigious Rufus Lathrop of Connecticut (1731–1805), probably a goldsmith, and they were married in 1757. They then lived in Connecticut. These portraits were painted in Norwich, Connecticut, by John Durand, one of the most stylish painters working in New England during the Revolutionary period. The portraits were given to the Choate family in Essex in the late 19th century and are now on display at Cogswell's Grant. Rufus writes about Hannah's portrait to her family after death in 1785 saying, "I am proud and gratified to have seen in the picture a good likeness of my wife while in her best health." (Both, courtesy Historic New England.)

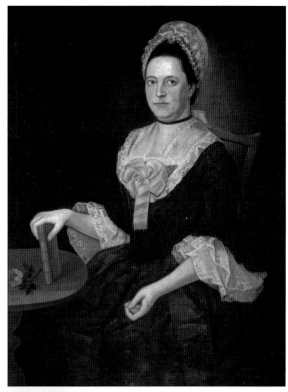

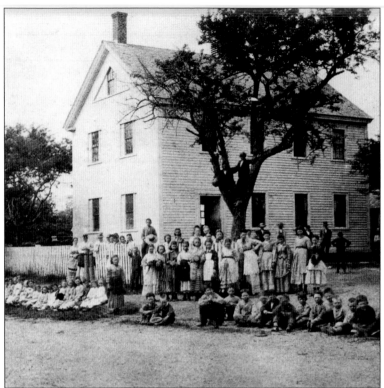

Center Primary and Grammar School is seen here in this mid-1870s photograph. Central Primary and Grammar School closed in spring 1894, and the students went to the new Rufus Choate School. The building was used as a meeting hall for the Civil War veteran organization, the Grand Army of the Republic (GAR), and was called the GAR Hall.

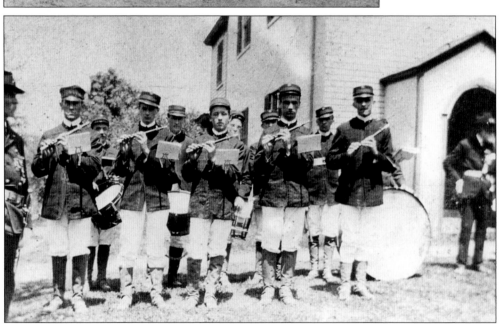

Here the Essex Drum Corps prepares for a Memorial Day parade. Pictured are, from left to right, (first row) fifers Wesley Burnham, Grover Dodge, Hartley Burnham, Frank Langell, and Lawrence Cogswell; (second row) Everett Lander, Bill Bray, Ben Lander, Marshall H. Cogswell, and Edward Andrews. Civil War veterans George Lendall (left) and Frank Nate Burnham (right) belonged to the local chapter of the GAR.

Civil War veteran Philip T. Adams was one of 50 GAR members of O. H. P. Sargent Post, No. 152, of Essex. Military service has always been important to this town. In 1969, an important military symbol was placed in Essex for many years. The town received the bell from the decommissioned aircraft carrier USS *Essex*. It was the fourth navy ship to carry this name. The first *Essex* was a 1779 frigate. The bell is now on the new *Essex*, commissioned in 1992.

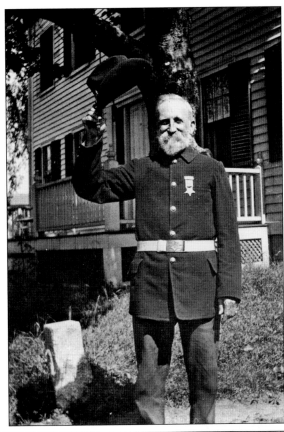

Some of the returning World War I veterans are at the 1919 Memorial Day service, assembling in front the GAR Hall, later to be known as the American Legion Hall. Stephen H. Meuse was the only one of the 75 World War I enlistees from Essex to be killed in action. He died of wounds received in action during the Meuse-Argonne offensive. The American Legion Post was named in his honor.

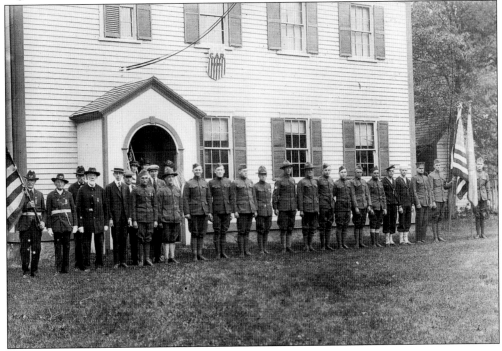

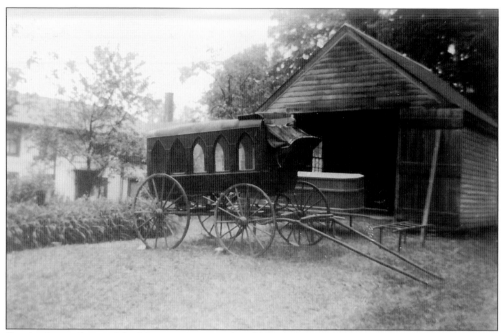

On display in front of the Hearse House at the old burying ground is a Gothic windowed hearse purchased by Essex in 1861 from Mr. Lock of Braintree. Underneath the Hearse House is said to be empty caskets of "not less than eight bodies," which had been disinterred and used for "anatomical purposes" by Dr. Thomas Sewall. His activities were discovered in 1818.

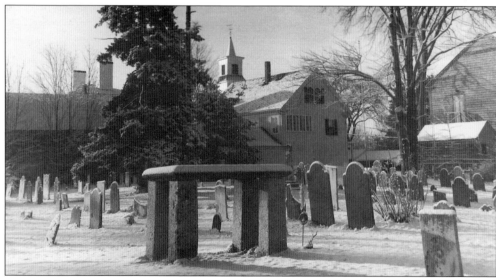

On February 15, 1680, one acre of ground was granted to Chebacco Parish for a burial place. The dead of Chebacco and Essex were buried in this small plot until a new cemetery on Spring Street was opened in 1852. Of the estimated 2,000 people buried here, there are now 374 headstones memorializing 424 people. The oldest gravestone remaining in the burying ground is that of John Burnham, who died January 11, 1708 or 1709, at age 59.

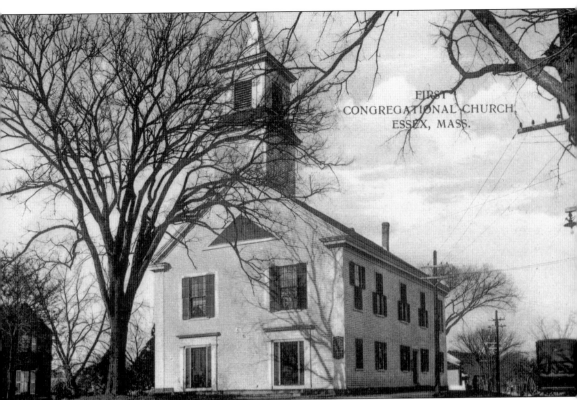

FIRST
CONGREGATIONAL CHURCH,
ESSEX, MASS.

The Congregational Church in Essex was formed in 1683 as the Second Church of Ipswich. At the time, Essex was known as Chebacco Parish, a neighborhood of Ipswich. The present structure was built in 1792 on the site of a previous church. It was remodeled in 1842 with an enclosed bell tower and a second floor sanctuary. Until a town hall was built in 1894, the selectman's office was in a corner of the first floor.

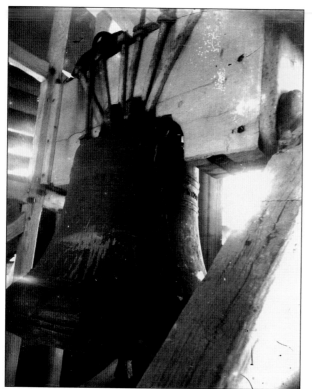

The bell hanging in the steeple is inscribed "Revere-Boston 1797." The people of Chebacco Parish contributed gold, silver, and jewelry to obtain this—the 19th bell cast by Paul Revere. It has marked many important occasions, deaths, marriages, calls to worship, and even lunchtime for the shipyard workers.

The Congregational Church choir poses for this Dana Story photograph in May 1935. Standing here are, from left to right, (first row) Florence Goodhue, Mae Lendall, Sylvia Gray, Katherine O'Brien, Frances Lambert, and Dr. E. A. Burnham, pastor; (second row) Olive Cleveland, Beatrice Cleveland, and Madeline Gray; (third row) Gilman Elwell, Stilson Cleveland, David Elwell, Arthur Wonson, and deacon Caleb M. Cogswell.

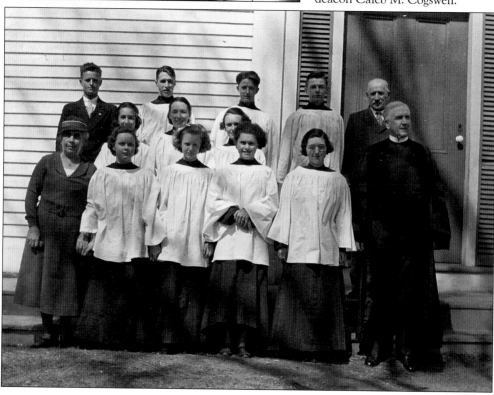

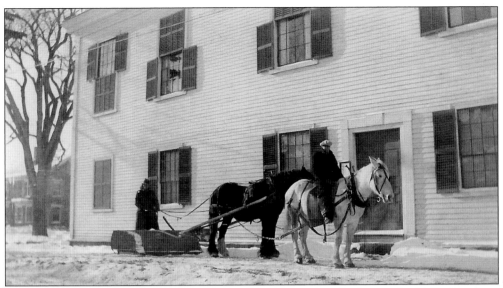

Frank Watson and his son are pictured with a two-horse sidewalk plow in this R. H. Burnham photograph taken around 1929.

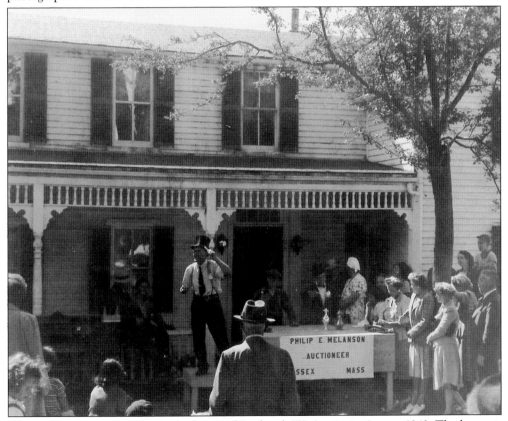

There was an estate auction at the home of Frederick W. Austin in August 1943. The house is located next to the Congregational church on Main Street. The auctioneer, Philip E. Melanson, also worked as a clammer in Essex.

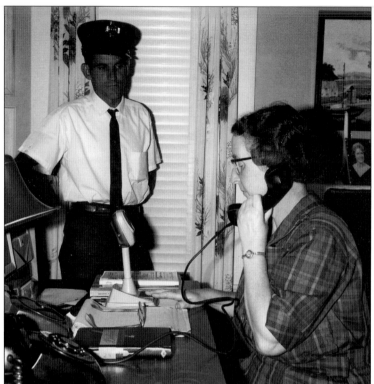

Fireman Norman Marcotti visits operator Dorothea Elwell at the emergency center in 1965. Dorothea, with a minimal amount of help, ran the town fire and police emergency center for approximately 17 years—24 hours a day, 365 days a year.

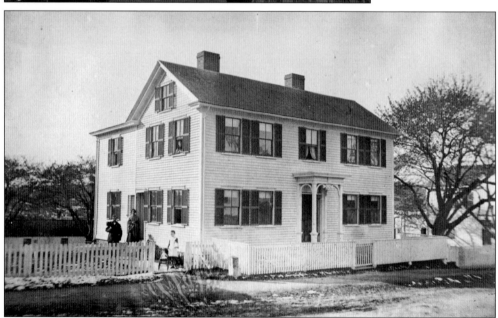

The Samuel Proctor house on Main Street was built in 1828. In this photograph, taken in October 1882, Maidee P. Polleys stands with her doll carriage at the side gate, while her mother, Sarah Polleys, is at the upstairs window. Maidee P. Polleys was a major contributor in the preservation and recording of Essex history. After Maidee Polleys died, the neighboring Congregational Church bought the house on December 30, 1965, for use as a parsonage.

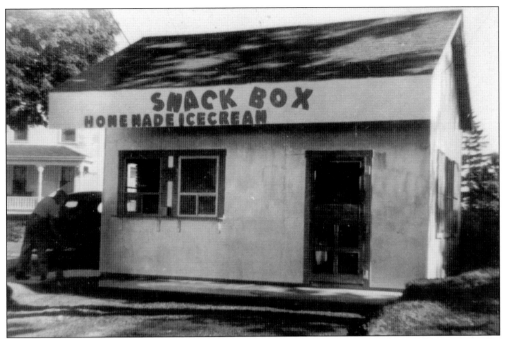

In 1947, the Snack Box shows little resemblance to the popular restaurant it would become—the Village Restaurant. Nearby at the right was a large house that belonged to Job Story. It was torn down in 1966, and the space became part of the restaurant parking lot.

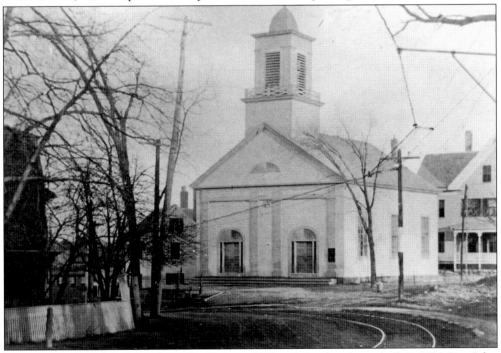

The Universalist Church was formed in Essex in 1829 and the church was built in 1836. Rev. John Prince, an early minister of this congregation (1840–1856), printed the *Essex Cabinet*, a weekly newspaper that lasted only one year in 1843.

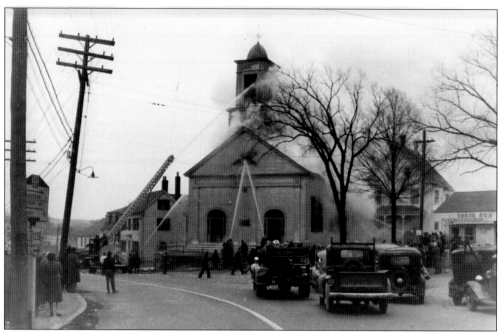

The Universalist church burned down on December 6, 1946. The big ladder truck at left is Gloucester Ladder 1. The church building was soon replaced by one of similar design. Note the sign at left which directs traffic towards Gloucester on old Route 128. The Snack Box on the right is now the Village Restaurant.

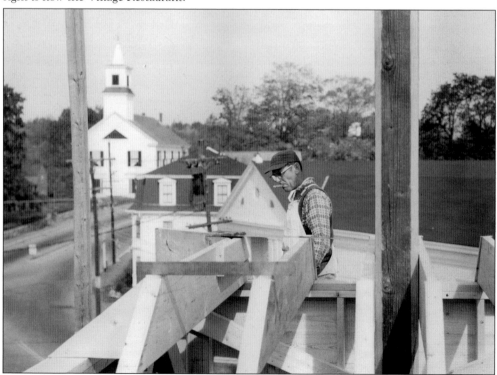

Arnold Cann is pictured building the steeple on the Universalist church in September 1963.

The building, erected in 1914 by A. D. Story, served as a bowling alley originally and faced the square. It was swung around following the rebuilding of Main Street in 1924. By the time this 1939 photograph was taken, the building had been converted to St. John the Baptist Roman Catholic Church.

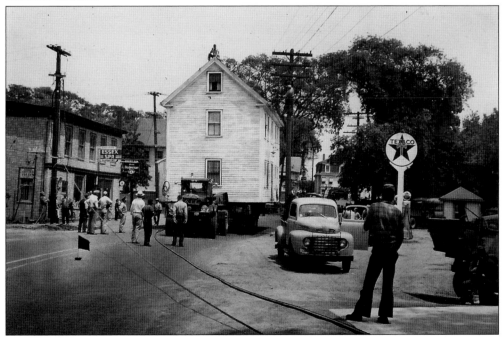

The Hubbard house was moved from behind the Catholic church to Prospect Street. House moving was more common in the past. For example, the Caleb Cogswell house was moved from the corner of Western Avenue and Pond Street to County Road, and Elston Lowe's store was moved down Main Street to Burnham's Corner.

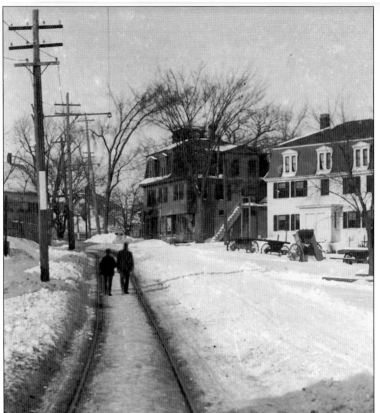

In this 1905 winter photograph of Main Street, taken near the town landing, one can see that the trolley tracks have been plowed, but the rest of the road is left snow covered so that sleds could be used instead of wagons.

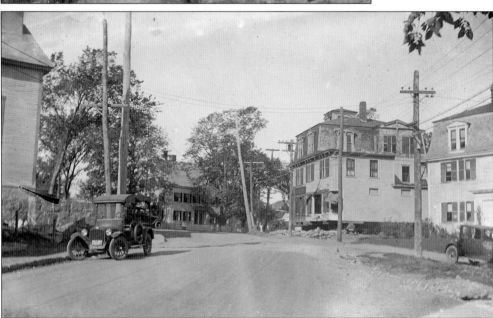

Main Street at the square was reconfigured in 1923 and 1924. A mansard roofed house, which once stood where the Catholic church is now located, is being prepared for a move down the street to the bridge, at the present site of Periwinkles Restaurant.

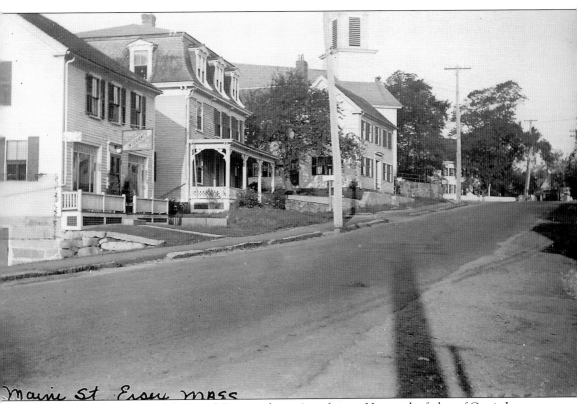

Maine St Essex mass

Timothy Andrews owned the Hotel Essex in the center of town. He was the father of Carrie Low Andrews. On February 3, 1894, Carrie, a very promising singer, was murdered by her deranged ex-fiancé at age 18 while attending voice lessons in Boston. The murderer, Walter Johnson of Gloucester, then killed himself.

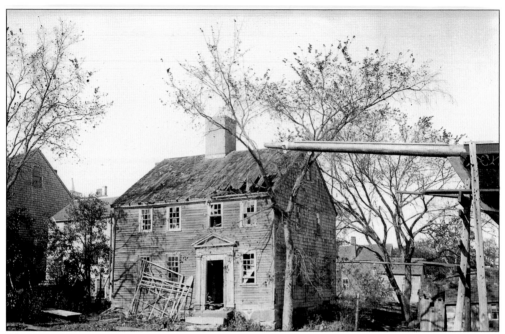

The Stephen Boardman house was built in 1783. Job Story and Adam Boyd had a shipbuilding partnership here. They were the two most active and prominent shipbuilders of their time. The house later fell into disrepair and was taken down shortly after this 1915 photograph. The foundation was used for a new shop in the A. D. Story shipyard. That shop was converted in 1953 to the home of Dana Story. It is now part of the Essex Shipbuilding Museum.

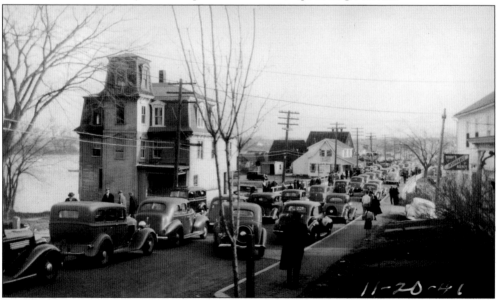

Crowds gathered on November 20, 1941, for the launching of the fishing schooner *Theresa M. Boudreau*. Launchings often attracted large crowds; sometimes thousands attended the events. The Victorian house at left was moved to that site from where the Catholic church now stands. The house was demolished in the 1950s, and the Skipper's Galley restaurant replaced it (now Periwinkles).

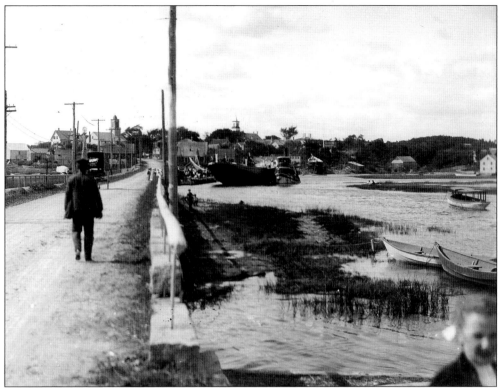

In this photograph, a tugboat prepares to take the *Arethusa* downriver and to Gloucester for fitting out. The schooner was built in the James yard and launched September 25, 1907. Another schooner under construction in the Story yard appears to be almost ready for launching. Though the granite retaining wall and guard rail (center of photograph) was removed in 2010, the capstones will be reused, thus retaining the historic feel of the causeway seen here.

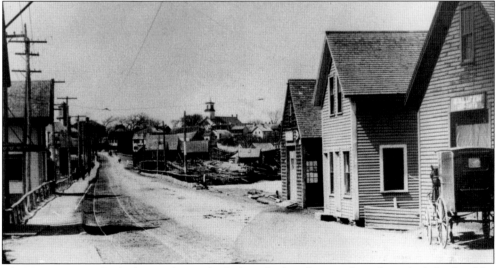

The causeway, as it looked around 1909, had a board sidewalk extending along the left side of the road. On the right are the Tarr and James Shipyard and the shops of O. O. Story (blacksmith), J. Turner (carpenter), and M. M. Lufkin (blacksmith).

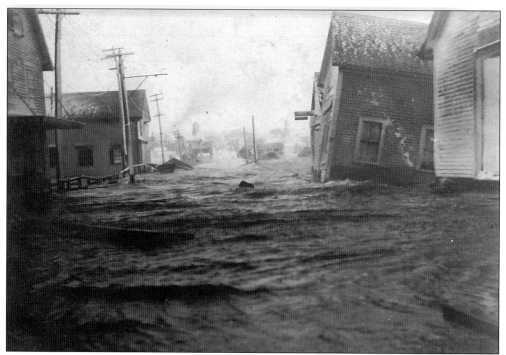

The Portland Storm on November 27, 1898, flooded the causeway and destroyed several buildings. It is said to have been one of the greatest storms to hit Essex. Other disasters have harmed Essex. An 1845 hail storm dropped ice chunks reportedly up to 7 inches thick and broke 3,000 panes of glass. Essex also experienced a few earthquakes that were violent enough to knock down stone walls and chimneys.

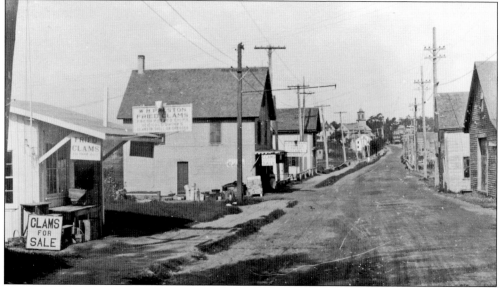

People traveled to Essex to get their clams as the clams that grow in the Essex River estuary seem especially sweet and succulent. Bill Preston's stand and Chubby Woodman's store with its sign advertising "L. H. Woodman's famous fried clams" are at left in this photograph taken about 1921.

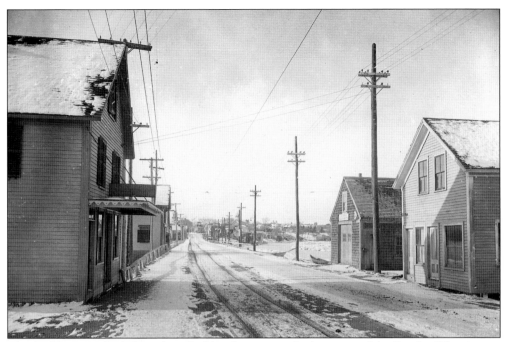

The building on the left is identified by the sign as the business of A. Stanley Wonson, an electrical contractor. The second building from the right was the blacksmith shop of O. O. Story, as it looked in 1911.

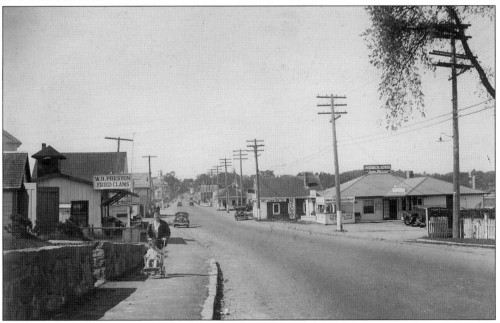

The causeway as it looked around 1934 shows W. H. Preston's fried clam stand on the left, with Woodman's Sea Grill just visible behind a telephone pole. On the right are the Riverside House along with the Dock Restaurant and the Bay Lobster Company in the former Otis O. Story blacksmith shop. The Essex causeway was and is a destination for anyone who wants to enjoy a nice seafood dinner.

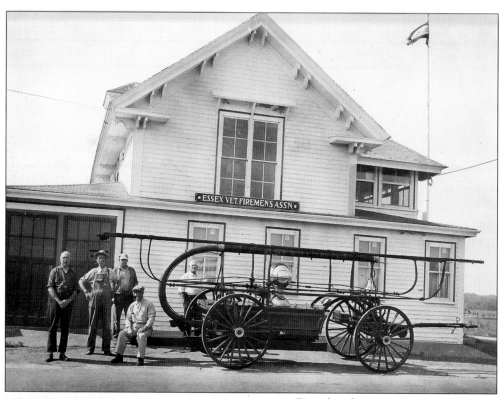

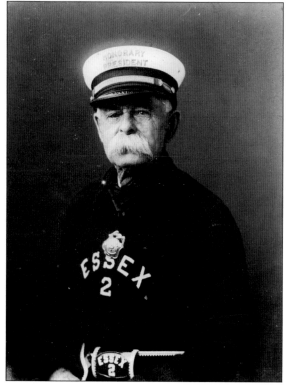

Essex hand pumper No. 2 was the primary firefighting equipment in Essex from 1880 until motorized engines arrived in 1920. After retirement from active duty, it was maintained by members of the Essex Veteran Firemen's Association for use at musters. Pictured in this 1946 photograph are, from left to right, George Reed, Charles Cogswell, Everett Meader, John Ellis (seated), and George Clark. This building is now part of Woodman's Restaurant, and the pumper, with the motto "We Will Try," is housed behind the fire station.

Luther Edwin Burnham was a ship caulker, working until he was nearly 90. His father, Luther Burnham, and his son, Luther T. Burnham, were also caulkers. Luther E. Burnham was also the fire chief for a number of years and active at the musters.

Five

ESSEX CENTER

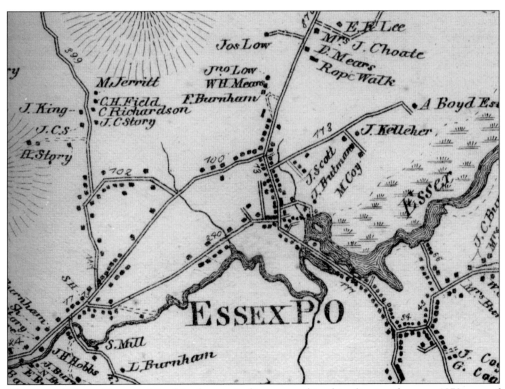

The part of Essex illustrated in this chapter is diagrammed in this clipping from an 1872 map of Essex. Massachusetts Route 133 runs from Ipswich at the top of the map, across the Essex River as Main Street, and through South Essex to Gloucester. This section covers those roads west of Main Street near Essex center, including Western Avenue, Story Street, Martin Street, Pickering Street, and Winthrop Street. In 1872, none of the streets that now connect Martin Street to Western Avenue existed or extended through.

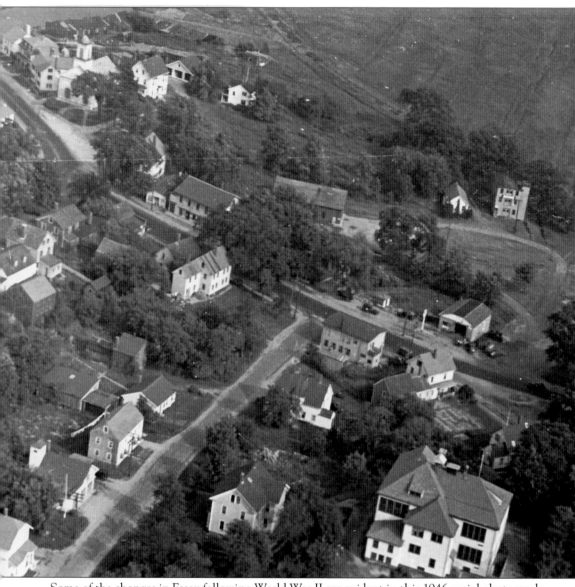

Some of the changes in Essex following World War II are evident in this 1946 aerial photograph of Essex center. Places no longer standing include the old Universalist church in the upper left on Main Street and the Abel Story house at the corner of Main and Martin Streets. Continuing down Martin Street were Richardson's Hall, Dr. Towne's house behind the trees, Terminal Garage, the Essex Spa across the street at the corner of Pickering and Martin Streets, and the Rufus Choate School in the lower right. By 1946, the high school students were sent to Gloucester High School, and the school was used for just the lower grades. In the old railroad yard behind Terminal Garage was Andrews's organ factory and the engine house, converted to a DPW building.

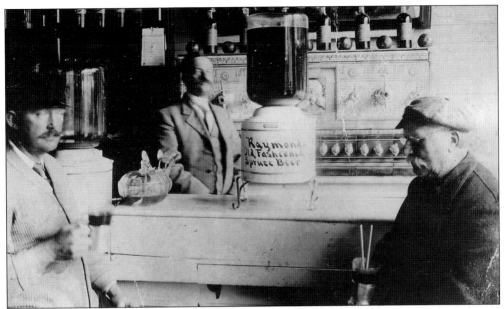

Customers enjoy a spruce beer at B. F. Reynolds apothecary (above) while across Martin Street, Rufus Choate (left) and J. M. Richardson (right) are pictured at Richardson's Store below in the early 1890s. The general store and post office were downstairs. Upstairs was a hall, which served many purposes for local gatherings. The hall was a high school while the new school was being built, a dance hall, a location for dance classes, a movie theater, a selectman's meeting hall before the town hall was built, and a meeting hall for a number of organizations, including the Grange. In fact, some associated the Grange meetings with this building so much that it was called the Grange Hall.

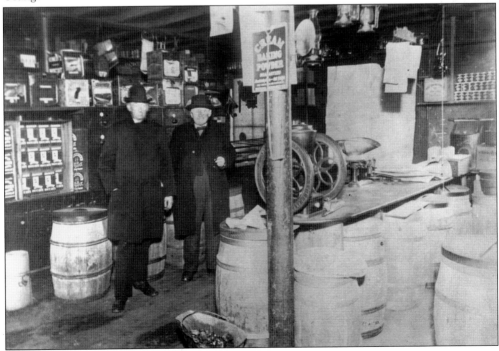

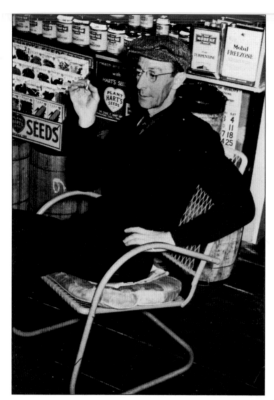

Carleton Perkins (1890–1978), son of Edwin C. Perkins, carried the rural mail for the 38 years between 1917 and 1955. In this 1942 photograph, he takes a short break to catch up on local news. Leighton Perkins's grocery and hardware store and the post office were in the same building, which made it a popular place to meet others.

Clarence S. "Cad" Perkins (1869–1943) was the postmaster for many years. He was the brother of Leighton Perkins, the grocer, and Edwin C. Perkins, a well-respected house and ship carpenter.

John E. Perkins, a grandson of Edwin C. Perkins, was also a postmaster. Pictured in summer 1942, he is at work in the old post office.

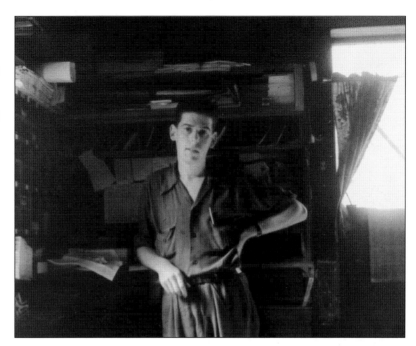

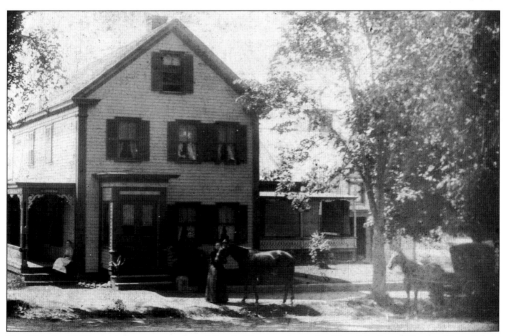

Dr. Charles S. Towne's house stood on Martin Street where the First National Bank of Ipswich is now located. After this house was demolished, this became the first site of Wedgewood Pharmacy and the site of the Essex Post Office. Over time, both of those entities were successively moved to the abutting lot on the left.

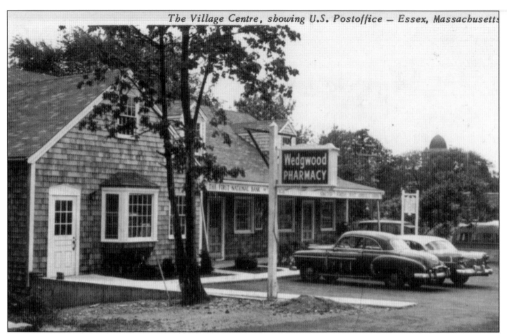

William and Teresa Eisenhauer razed a house on the lot that had been occupied by the Sawyer family, and they erected a new building in the center of town in 1957. The Village Center contained the Wedgwood Pharmacy, the First National Bank, and the post office. The bank was the first one to operate in Essex. The post office was moved from Grange Hall.

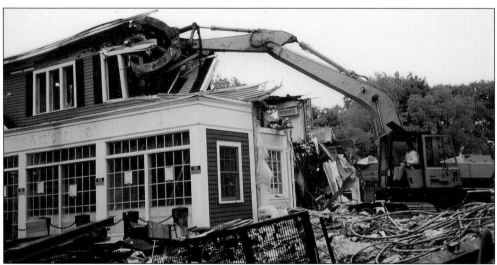

The move of the post office to a new building next door and a fire in the bank building led to the demolition of the building in June 2001. It was replaced by a new, brick building for the First National Bank of Ipswich. At the same time, the Terminal Garage building was demolished to make way for a bank training facility, office building, and apartment space.

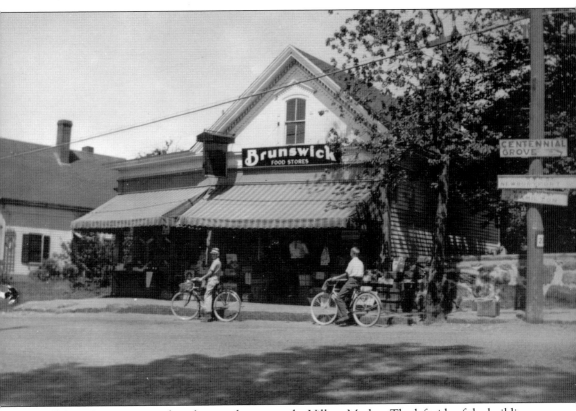

Will Swett's grocery store later became known as the Village Market. The left side of the building was the trolley car waiting station before 1920. Sanford Young and David Smallidge are on their bicycles. The house on the far left of this picture was demolished in 2009 after being vacant for over 20 years.

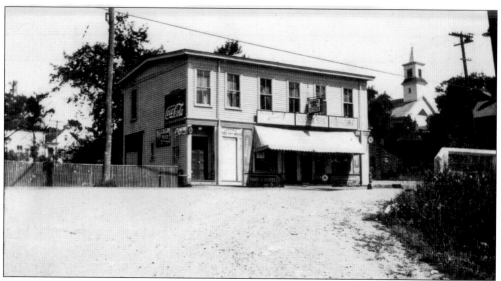

A fire destroyed the second floor of Bill Vasiliadis's Essex Spa. For a couple years, it continued business in the remaining first floor, but the structure was finally sold and demolished, and a bank building was constructed here at the corner of Martin and Pickering Streets. The bank, formerly Ipswich Savings Bank, is now TD Bank.

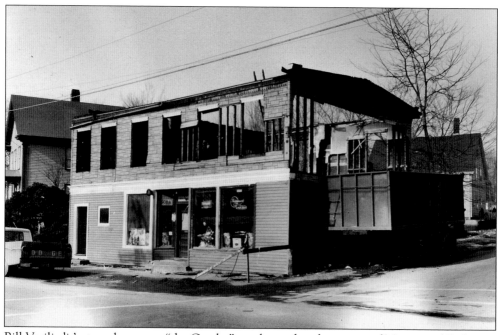

Bill Vasiliadis's store, known as "the Greeks," was located at the corner of Martin and Pickering Streets. In the back of the store was a bar called the Essex Spa. The upstairs was used as a meeting room for various organizations.

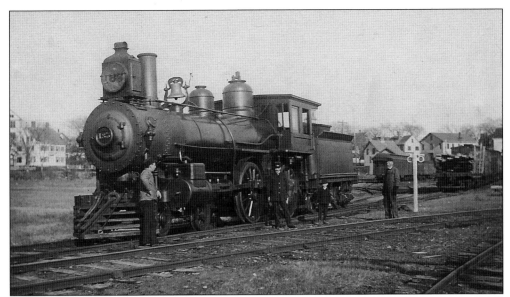

Standing beside engine No. 183 in this view of the Essex yard from around 1900 are, from left to right, the brakeman; the conductor, John Buckley; a boy; and the engineer, Phil Adams. The flatcar in the background carried ship timber. Philip T. Adams ran the Essex branch locomotives for 38 years. He worked on the route from the day it opened on July 1, 1872, until his death at a rail yard in Somerville in 1910.

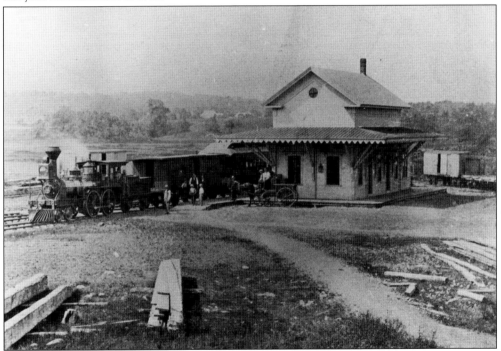

The Essex Depot began operations in 1872. The Essex branch carried freight and passengers in and out of Essex until the line closed in 1942. There were stops at Centennial Grove and Essex Falls and later at Conomo Station in South Essex. The yard had an engine house, freight house, and a turntable.

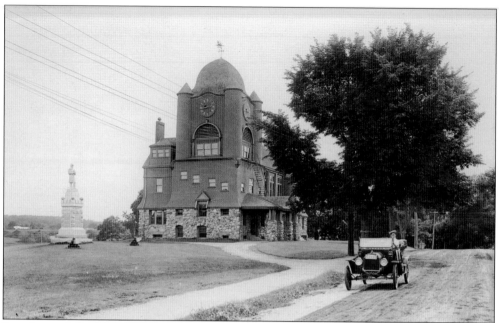

Benefitting from a large donation by T. O. H. P. Burnham, a town hall was built in 1893 and dedicated in 1894. The stones in the first story of the building have been referred to as memorial stones. They were given by people of Essex and surrounding Cape Ann in memory of some particular person or place. Through the efforts of the Women's Relief Corps (a GAR auxiliary organization), a Civil War monument at left was erected in 1905. (Courtesy Historic New England.)

Since the town hall was being planned and built about the same time of the 400th anniversary of the discovery of America, the weather vane was designed to mark the occasion with a representation of the *Santa Maria*.

Essex and Gloucester officials were photographed "perambulating the boundary" in 1900. Standing are Mayor Robinson of Gloucester, Essex selectmen John P. Story and Frank E. McKenzie, and engineer Webber. Alderman Marchant is painting the white oak boundary marker.

Frances Lowe was town librarian for 30 years. Here at her retirement party are, from left to right, Margaret Story, Abby Stoddard, Frances Lowe, and Elizabeth Joseph. Story was library trustee for 24 years, and Stoddard became vice president of John Hancock Life Insurance Company.

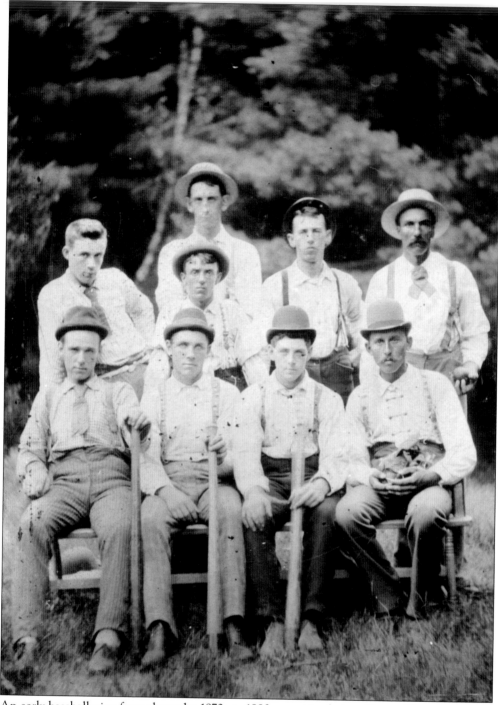

An early baseball nine from about the 1870s or 1880s poses in their uniforms. This photograph may have been taken at the Centennial Grove field.

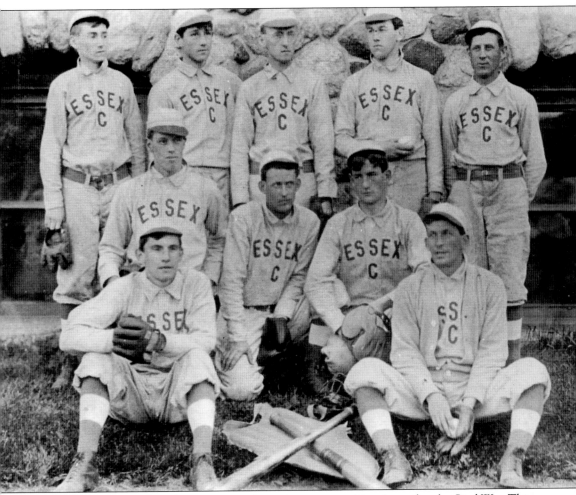

Town baseball teams have been very popular and very competitive since after the Civil War. This team from 1908 included, from left to right, (first row) Carleton Gaffney and Percival Burnham; (second row) George "Sammy" Gray, Stanwood "Needles" Burnham, and Ward Wetmore; (third row) Ralph "Bobby" Low, Fletcher Low, William Low, Lyndon "Ginnis" Story, and William Ross. Fletcher Low played on the Boston Braves professional baseball team after graduation from Dartmouth College.

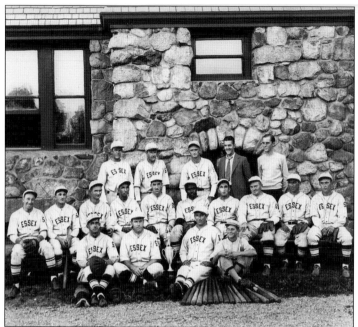

On this Essex team from 1932 are, from left to right, (first row) Tom Boutchie, manager Lyndon "Ginnis" Story, Jim Mulcahy, and batboy Leo Doyle; (second row) Louis "Custard" Boutchie, Isadore "Zacky" Boutchie, Leo April, Ivan Muise, Eddie Doyle, Sam Thompson, Bill Boutchie, Arnold "Joe" Bennett, Clarence Mulcahy, and Charlie Mulcahy; (third row) Everett Henderson, Weymouth Lufkin, Raymond Mulcahy, Asa Hammond (in suit), and Jimmy Hoskins.

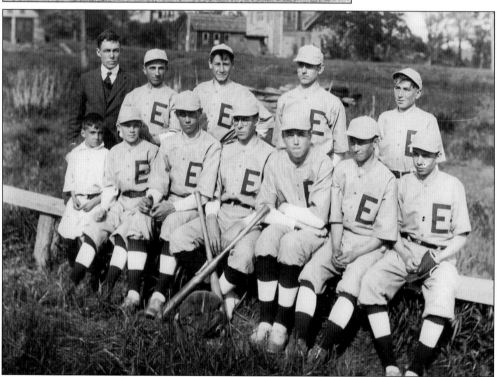

The 1923 Essex High School team photograph was taken at the ball field behind town hall. Pictured here are, from left to right, (first row) Ivan Muise, Russell Doyle, Norman Nickerson, Ellsworth Brown, Bob Goodhue, Jim Mulcahy, and Millard Tucker; (second row) principal George Henry Durgin, Bill Boutchie, Sherman Mears, Pete Comeau, and Norman Gilbert. The railroad engine house (at left) and the vacant clam canning factory are in the background.

Members of the 13th Company, 24th Infantry, Massachusetts State Guard who were present for the 1943 Memorial Day services were, from left to right, Lt. Theodore (Ted) Burnham, Sgt. H. Foster Andrews, Cpl. Jim Waddell, Melvin Gaffney, Cpl. Donald Goodhue, Cpl. Rudolph Foss, Sgt. William Eisenhauer, Cpl. Jim Robinson, and Sgt. Dana Story.

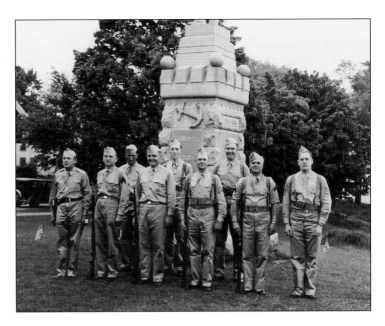

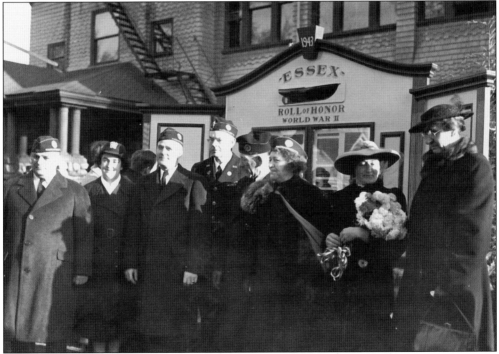

Dana Story designed an Roll of Honor, which was dedicated on November 14, 1943. Among those taking part in the ceremony were, from left to right, Harvey Cook, Ens. Mary E. S. Barr, American Legion commander Martin Morrissey, Harold Wilson, Arthur Mears, Annie Mears, Elizabeth Cummings (she had four boys in the service), and Myrtle Goodhue (mother of Herbert Goodhue, who was killed at Bataan).

A fireman's muster in August 1947 lends a carnival atmosphere to Shepherd Memorial Park. Many local men participated in the musters. The endurance needed to keep up pressure made it an athletic event, as much as it was an event to show the ability of the equipment. It was also a dangerous sport. An Essex man, Albert April, was killed when the pressure tank blew apart.

Jim Melanson drives a yoke of oxen owned by George G. Perkins. Agriculture, once an important part of community life, is quickly fading from memory. The hills were cleared of trees, partitioned with stonewalls, and used as pastureland. Major enterprises in Essex were salt marsh haying, poultry farms, and dairy farms.

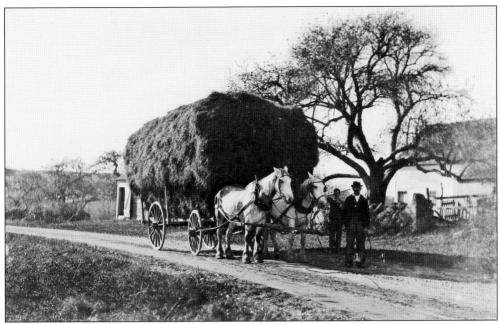

Ed Knowlton, who lived on Western Avenue near the Falls, takes a load of hay past the Story farm on Western Avenue in the early 1900s.

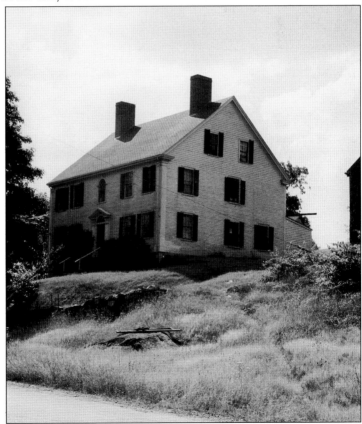

This 1799 Western Avenue house was built for the newly appointed Congregational minister, Rev. Josiah Webster. He graduated from Dartmouth College the year before and accepted the ministry with enthusiasm. He was deeply concerned with education, and since he was aware of the evils of a strong drink, he often preached against intemperance. Reverend Webster decided to return to New Hampshire in 1808 due to the inadequacy of his financial support at Chebacco.

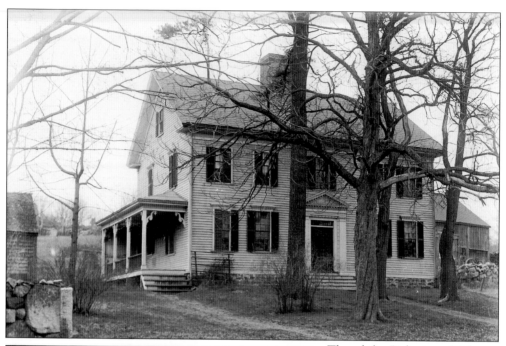

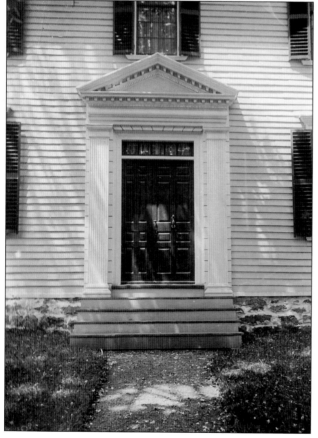

Theophilus Pickering of Salem graduated from Harvard College in 1719. Upon the death of Rev. John Wise, Reverend Pickering was ordained as the second minister of the Chebacco Church in 1725. He had this house built in 1730, reportedly doing much of the interior work himself. In 1727, Chebacco and the surrounding area experienced "the Great Earthquake." This great fright was followed by a revival of religion, and Reverend Pickering's congregation increased from 91 to 177 members. In 1740, a much greater surge of religious fervor occurred to those who heard George Whitefield preach in town. This revival led to a separation of the Chebacco Church in 1744, and the church remained separate until reunited in 1774. Reverend Pickering died in 1747 at age 47.

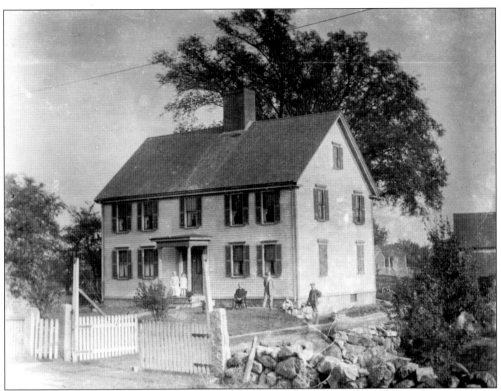

In 1643, Thomas Low had 20 acres of land assigned to him in Chebacco. This grant included the land on which this house stands, which was Low property until sold to the Wyeth family in 1911. This house was built about 1720. It was, as Maidee Polleys wrote in 1939, one of those that was built for the centuries by honest hands in Puritan plainness of design. Daniel Low (1749–1824) and his son, Winthrop (1785–1866), were the wealthiest people in town in their time.

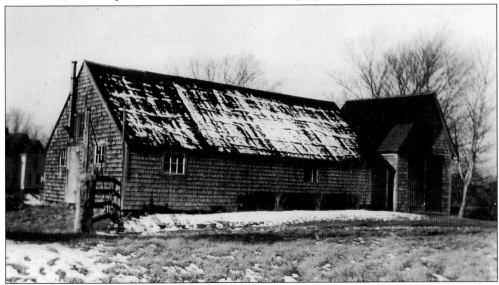

This very old malt house was one of two known to ever exist in Essex. The other was at Cogswell's Grant. This barn was later used for hooked rug classes around 1950, held by Stella Bishop.

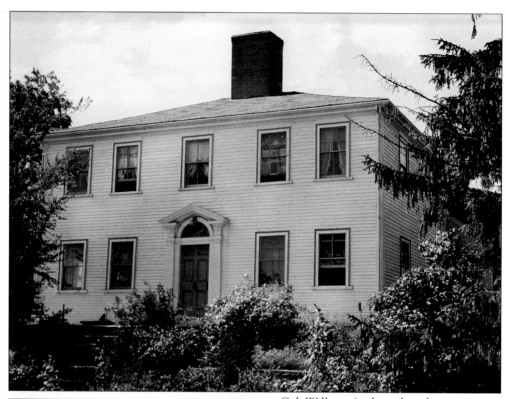

Col. William Andrews bought a piece of land from Thomas Burnham in order to build this house in 1803. In the 1860s, Epes and Aurelia (Story) Story bought the house and surrounding property. Aurelia Story (1841–1941) lived to within a couple months of her 100th birthday. Her daughter, Marion (Story) Barr (1879–1979), also died just short of her 100th birthday. Marion Barr lived her whole life at that house.

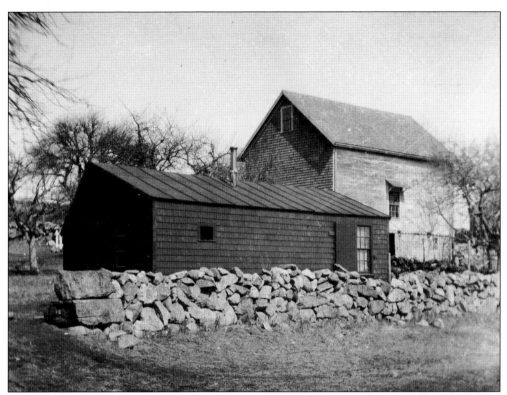

The photography studio of Edwin James Story was built in 1905 and torn down in 2007. Most of the early Essex photographs available today came from the studio of "Eddie James." The barn in the background still stands. It is located on Western Avenue near Story Street.

Through his photography, Edwin James Story (1863–1956) is responsible for preserving the way Essex looked from the 1880s to the 1930s. He was also a ship carpenter and a musician. He married Ellen Story, daughter of Epes and Aurelia Story, and they lived at the home of her parents.

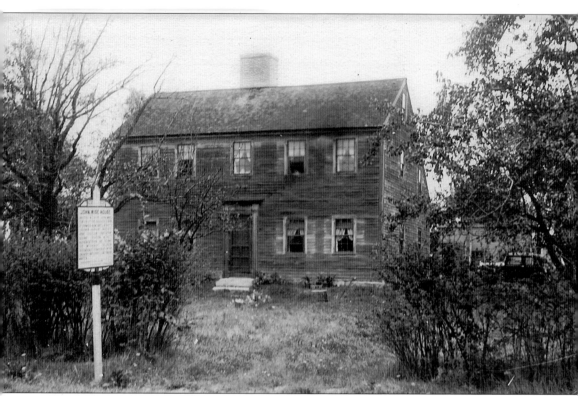

Pictured is the John Wise house, built in 1703. Rev. John Wise, Chebacco's first minister, is a perfect example an early American patriot. He was a famous orator, successful wrestler, strong social leader, and he even joined a military expedition to Canada. After hearing Cotton Mather explain the smallpox inoculation, he became one of its only advocates, at a time when most people could not comprehend such forward-thinking medicine. He is also called the father of American independence, because in 1687 he led the first American revolt against taxation without representation. He was jailed, but later released, and he successfully sued for damages.

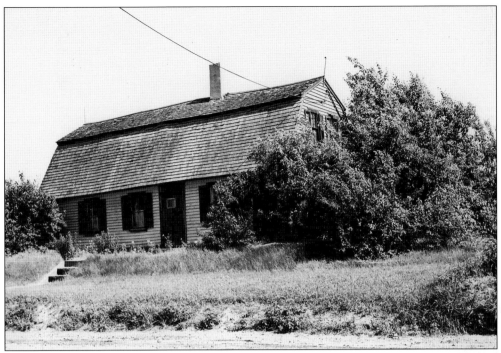

This is the Jesse Story house on Story Street. A cannonball at the Battle of Bunker Hill killed him. The cannonball was saved and is now at the Essex Shipbuilding Museum.

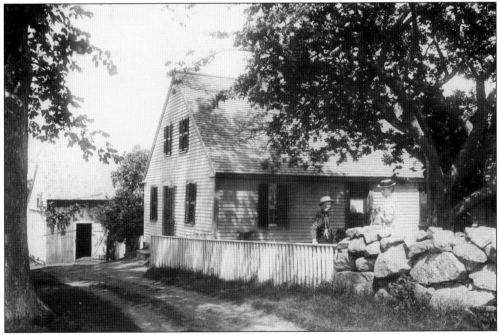

This cape-style house on Story Street, across from Belcher Street, was built in 1780 and became a McKenzie homestead in 1809. Jacob McKenzie and his daughter, Helen McKenzie, are standing in the front yard. This section of Story Street was settled very early. The 17th-century route to Manchester passed by this house and on to Essex Falls.

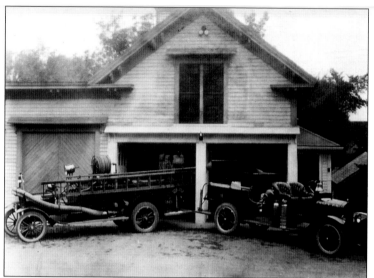

The fire station for Essex center was on Pickering Street. South Essex had an engine house on the causeway. This photograph, taken about 1925, shows the pump truck and the chemical truck with a supply of fire extinguishers. The top of the hose tower is seen at the back of the engine house. Oddly, it appears that the left bay door opens inward.

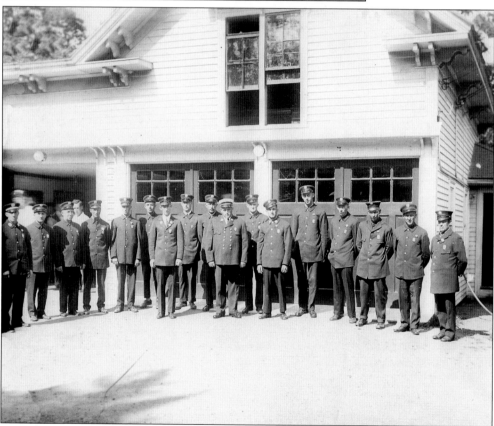

Members of the volunteer fire company prepare for the 1930 tercentenary parade at the Pickering Street engine house. Pictured here are, from left to right, Louis Boutchie, Isadore Boutchie, Everett Lander, Jessie Correia, Eddie Andrews, Skeet Doyle, engineer Arthur Hotchkiss, George Story, Albay Muise, chief Lawrence Woodman, Raymond Mulcahy, engineer Tom Boutchie, Howard Haskell, Chester Boyd, Dave Gosbee, Clarence Mulcahy, and Sammy Gray.

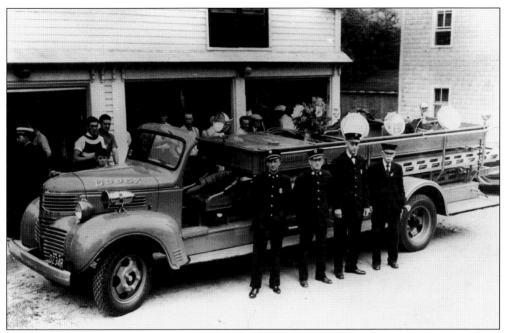

Delivery of a new Ladder 1 at the Pickering Street engine house in 1940 is formally accepted by, from left to right, George Towne, chief Tom Boutchie, Howard Haskell, and former chief Luther E. Burnham. The cab is not enclosed to provide better visibility for the driver.

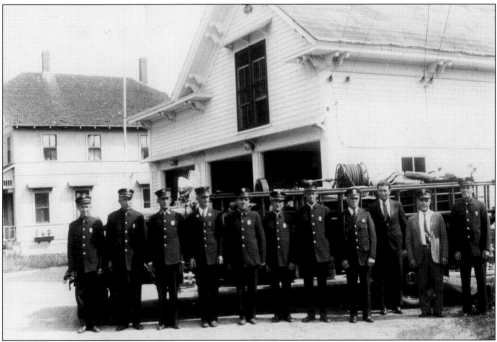

Essex firemen posing in front of the new Dodge Engine 1 are, from left to right, Clarence Mulcahy, Albay Muise, Tom Boutchie, Arthur Hotchkiss, Bill Boutchie, Isadore "Zack" Boutchie, Lawrence "Turk" Story, Louis Boutchie (also police chief), Jim Mulcahy Sr., John Ellis, and Russ Doyle. This photograph of the Pickering Street engine house was taken in 1935 by E. J. Story.

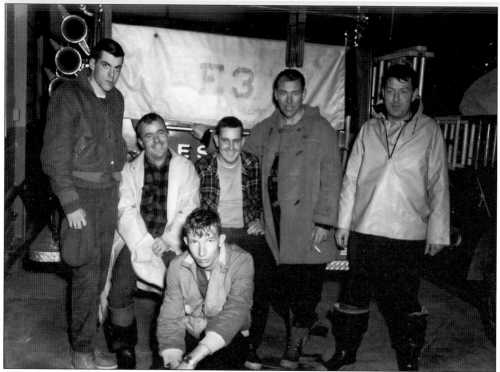

Some of the firemen who responded in search of a lost boy in 1964 were, from left to right, Leonard Woodman, Pat Noonan, George Lufkin, Harold Addison, Roger Ball, and Danny Muise (kneeling). The Essex volunteer firemen have an excellent reputation for their quick response time to emergencies and for their professionalism.

Winthrop Street was developed in the mid-1870s from the Winthrop Low farm. This photograph was taken around 1885 from the studio of E. J. Story. It truly is remarkable to view these treeless photographs from the late 1880s and compare them to the scenes of today. Except for the last house at right, which was the Everett James house, most of the other houses belonged to members of the Story family, including A. D. Story, Lyndon Story, and John Prince Story.

According to tradition, a liberty pole was placed on Martin's Rock during the Revolutionary War. In this 1872 photograph, it is evident that this location continued to be a place to fly the country's flag. In 1894, the rocky outcropping was removed, and Essex High School was built on the hill.

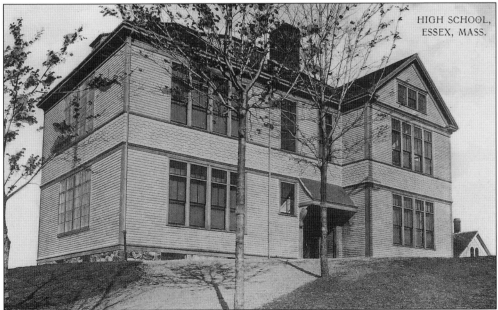

HIGH SCHOOL, ESSEX, MASS.

There was no public high school education in Essex before 1890. Any student wishing to attend advanced schooling had to attend a private academy. The only Essex high school building was dedicated in 1891, and there were 12 students in the first graduating class in 1894. The building was named the Rufus Choate School in 1930. From 1942 until the 1981, Essex teens went to Gloucester High.

Lucille Benson was the seventh grade teacher at the Rufus Choate School in 1931. Dexter Woodman and Rachel McIntire look on as she prepares for the last day of classes. The Rufus Choate School remained open for grades one through eight until 1956. Students met at the town hall and Grange Hall until the new school on Story Street was ready.

The undefeated Essex Elementary school basketball team of 1965 included, from left to right, (first row) Fred Markham, Joe Ginn, Gary Stone, Steve Woodman, and John Marshall; (second row) Mark Osborne, Sandy Corrao, Phil Cummings, John Duncan, Billy Moore, and coach Thomas Buonaugario. Essex Elementary School has been the only school in Essex since it opened in 1958.

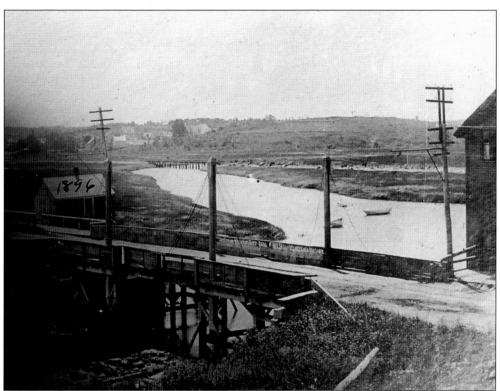

The old drawbridge over the Essex River is pictured in this 1896 photograph. Some of the remains from a mill can be seen downriver from the bridge. There have been sawmills, gristmills, and a fulling mill at this tidal location. Above the bridge is the train trestle leading "over river" to Conomo Station. Noah's Hill, a treeless pastureland, forms the horizon. The commercial building at right was called the Red Lion.

Willfred W. Lufkin was a Massachusetts congressman who lived on Winthrop Street. He was private secretary for Congressman A. P. Gardner, and when Gardner resigned due to ill heath, Lufkin was appointed to fill the vacancy. He served in congress from 1917 to 1921, when he resigned to accept appointment as collector of the Port of Boston. He was succeeded in office by A. Piatt Andrew.

Dana Story (1919–2005) sits in his father's float in the 1930 Massachusetts tercentenary parade. After a career as a shipbuilder, he became a town historian and an author who preserved the shipbuilding heritage of Essex. He donated his large collection of photographs to the Essex Shipbuilding Museum. Many of those images are included in this volume.

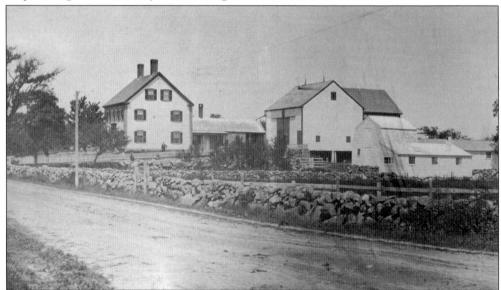

The David Mears farm on John Wise Avenue is now much different in appearance than in this 1890s photograph. A ropewalk is seen at the right edge of the photograph. There were several ropewalks in town. The W. H. Mears had one near the town pound, and generations of Hardys had one on Island Road and between Main and Pickering Streets, which was taken over by W. H. Mears in 1887.

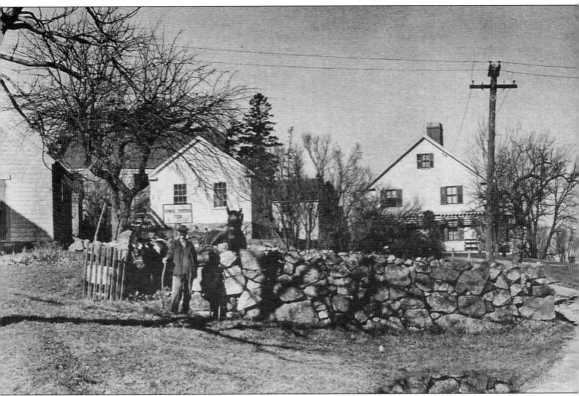

The town pound was built in 1725 and was enclosed with stonewalls. It is located near what was once the town green and training field on John Wise Avenue. A new, and larger, meetinghouse was built near here in 1720 and was used until 1774. Also nearby is the house where the first school in Essex was established in 1695 with Nathaniel Rust Jr. as teacher.

www.arcadiapublishing.com

Discover books about the town where you grew up, the cities where your friends and families live, the town where your parents met, or even that retirement spot you've been dreaming about. Our Web site provides history lovers with exclusive deals, advanced notification about new titles, e-mail alerts of author events, and much more.

MADE IN THE

Arcadia Publishing, the leading local history publisher in the United States, is committed to making history accessible and meaningful through publishing books that celebrate and preserve the heritage of America's people and places. Consistent with our mission to preserve history on a local level, this book was printed in South Carolina on American-made paper and manufactured entirely in the United States.

This book carries the accredited Forest Stewardship Council (FSC) label and is printed on 100 percent FSC-certified paper. Products carrying the FSC label are independently certified to assure consumers that they come from forests that are managed to meet the social, economic, and ecological needs of present and future generations.

FSC
Mixed Sources
Product group from well-managed
forests and other controlled sources

Cert no. SW-COC-001530
www.fsc.org
© 1996 Forest Stewardship Council

Find Your Place in History.